THE · NEW BRITISH PAINTING

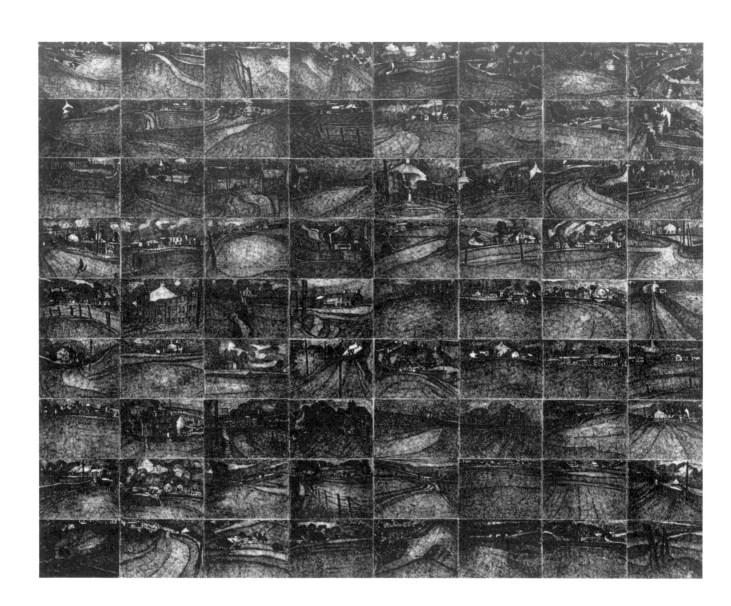

THE · NEW BRITISH PAINTING

Edward Lucie-Smith
Carolyn Cohen
Judith Higgins

PHAIDON · OXFORD

THE CONTEMPORARY ARTS CENTER
CINCINNATI

Phaidon Press Limited, Littlegate House, St Ebbe's
Street, Oxford OX1 1SQ

First published 1988
© Phaidon Press Limited 1988

British Library Cataloguing in Publication Data

The New British painting.
 1. British painting.
 I. The Contemporary Arts Center, Cincinnati,
 Ohio
 759.2
 ISBN 0-7148-2574-3
 ISBN 0-7148-2517-4 Pbk

Printed in Great Britain
by Balding + Mansell UK Limited

Published for the exhibition *The New British Painting*,
organized by The Contemporary Arts Center,
Cincinnati:

The Contemporary Arts Center, Cincinnati,
18 November 1988–7 January 1989

Chicago Public Library Cultural Center,
21 January–25 March 1989

Haggerty Museum, Marquette University,
Milwaukee, Wisconsin,
27 April–3 July 1989

Southeastern Center for Contemporary Art,
Winston-Salem, North Carolina,
4 August–1 October 1989

Grand Rapids Art Museum, Michigan,
17 November 1989–1 January 1990

Notes on *The Artists* (pp. 108–9) have been compiled
by Edward Lucie-Smith. A number of the entries
were first published in S. Kelly and E. Lucie-Smith
The Self Portrait: A Modern View (Sarema Press,
London, 1987).

Frontispiece. John Virtue. *Landscape No. 8.* 1980–4

CONTENTS

FOREWORD

The idea for *The New British Painting* came from a conversation I had with one of the exhibition's eventual curators, Carolyn Cohen. In that conversation, we talked endlessly about how much activity there was in contemporary British painting and how little anyone outside the United Kingdom seemed to know about it. True, the art world knew about R.B. Kitaj and Lucian Freud, Frank Auerbach and Francis Bacon, but, in fact, most individuals were hard pressed to name those painters who comprise the generation that has come after these artistic giants. We decided that an exhibition exploring recent developments in British painting was a worthy and timely project.

It was decided that the best approach to such a venture into this relatively uncharted territory was to use two curators: one British, who could supply a first-hand knowledge of those artists who had been attracting interest in the United Kingdom; and one American, who could provide a fresh 'eye' to the British scene. Edward Lucie-Smith, critic, writer, and keen observer of the British art world was a natural choice in the UK. Carolyn Cohen, a former curator at the Jewish Museum, New York, and an individual with considerable experience with young artists on both sides of the Atlantic, was Lucie-Smith's American counterpart. During the course of organizing the exhibition, which took over a year-and-a-half, they criss-crossed England and Scotland viewing the paintings of more than 120 artists whose work had caught their attention or that of the dozens of curators, critics and dealers with whom they consulted. In the end, the hundreds were pared down to twenty-six artists—all between the ages of twenty-four and forty-two—who are among the best and most innovative of Britain's new generation of artists.

The exhibition has created considerable excitement and support in Great Britain. Among the many people involved, a number of individuals and institutions should be singled out for their co-operation. Henry Meyric Hughes, Director of the Fine Arts Department of the British Council, has offered tremendous help and guidance. Under Henry's direction, the Council has provided us with substantial support, for which we are extremely grateful.

In the United States, the receptivity of US museums toward the exhibition has been surprisingly cool. For many, perhaps, the territory of contemporary British painting was just too unknown, as it has not yet received the press or the recognition that art from Germany and Italy have experienced in recent years. Support has, however, come from four institutions: The Chicago Public Library Cultural Center, Greg Knight, Director of Visual Arts and Chief Curator; the Haggerty Museum, Marquette University in Milwaukee, Curtis L. Carter, Director; the Southeastern Center for Contemporary Art, Winston-Salem, North Carolina, Ted Potter, Director; and the Grand Rapids Art Museum, Michigan,

Dennis Komac, Director. All have agreed to make the British painting show a part of their schedule.

Whether in the United Kingdom or the United States, the lenders to the exhibition have come forward with great enthusiasm. All are proud of these young artists and feel they will make a significant contribution to the international art world in the future. For most of these lenders, parting with their works for so long is a hardship but also an act of real commitment to the artists and their work.

The catalogue documenting this important work has been an integral part of the exhibition from the onset. Edward Lucie-Smith's essay sheds new light on the historical background to contemporary painting in the United Kingdom. Carolyn Cohen not only curated the exhibition, but has also written a detailed, informative description of the artists and the works in the show. And Judith Higgins, an American art critic and contributing editor for the magazine *Artnews*,

has written an essay that offers an American view of the new painting and discusses its particular qualities. We have been honoured to work with Phaidon Press of Oxford, England, in the co-publishing of this handsome book. Roger Sears and Ruth Maccormac of Phaidon Press have been invaluable in their guidance and assistance. Here at home, Sarah Rogers-Lafferty, Curator, Jan Riley, Assistant Curator, and Carolyn Krause, Publications Co-ordinator of the Center's staff have all facilitated the processing of the loans, the editing of the texts and the production of the catalogue.

Through this exhibition, we hope not only to bring the diverse talents of this generation of British artists to the attention of the American public, but also to provide an exciting forum for discussion and evaluation.

Dennis Barrie
Director
The Contemporary Arts Center, Cincinnati

Many of us feel that recent British painting has received less international attention than it deserves. This may be on account of the notable success of the new British sculpture, to which the touring exhibition *A Quiet Revolution* bore witness in the United States. It may also be attributed, in part, to the richness and diversity of the work itself and the difficulty which critics have experienced in trying to place it in an appropriate context.

It may be that we are still too close to events to be able to distinguish clearly between different tendencies, and it is only to be expected of young artists that they will continue to evolve in sometimes surprising directions. However, the selectors of this exhibition, Carolyn Cohen and Edward Lucie-Smith, have been as determined in their insistence on quality, freshness and originality as they have been assiduous in their efforts to find it, in galleries and artists' studios across the country.

The selectors have made no effort to conceal their bias towards figurative painting or their belief that much of the most innovative

work in Britain today is being done in this area. For all that, this is a well-informed, catholic and balanced selection which, it seems to me, brings out the following essential aspects:

1 the reaction against international styles and the reductionist tendencies of the 1970s;

2 the use of a wide referential framework (one of the principal gains of the 70s), which is enhanced by an extension of emotional range and the inclusion of autobiographical, narrative, historical and mythical subjects;

3 the revaluation of a native British tradition, extending backwards beyond the Neo-Romantics to Blake, Palmer and the nineteenth-century Romantics, accompanied by an affirmation of subjective and regional elements;

4 an awareness of parallel tendencies in contemporary European art, starting with the Trans-avantgarde and *Neue Wilden*, with a sidelong glance at conceptual and

7

performance art, and extending backwards to the Renaissance.

These artists resort to easel painting and figuration, less as an escape into the past or an exercise in nostalgia than as a means of re-affirming their power to express and to question the values of the community to which they belong.

I should like to offer my warmest congratulations, not only to the selectors for their perceptive choice of artists but to Dennis Barrie, the Director of The Contemporary Arts Center in Cincinnati, for his courage and tenacity in seeing this bold project through to a successful conclusion, and to the directors of the four other arts institutions in Chicago, Milwaukee, Winston-Salem and Grand Rapids, to which the exhibition will subsequently travel. This is the fullest and most representative selection of the work of young British painters to have been shown overseas. I have no doubt that it will mark a turning point in the international appreciation of contemporary British art and in the fortunes of many of the individual participants.

Henry Meyric Hughes
Director, Fine Arts Department
The British Council, London

ACKNOWLEDGEMENTS

One of the most gratifying aspects of this collaboration has been the opportunity to work with Dennis Barrie and Edward Lucie-Smith. Dennis offered his encouragement and enthusiasm for the idea of this exhibition and Edward Lucie-Smith guided me through the project with his unparalleled knowledge of the British art world, expertise and scholarship.

The credit for seeing the exhibition and catalogue projects to fruition belongs to the entire staff of The Contemporary Arts Center: Sarah Rogers-Lafferty, Curator, who was my constant source of support, and who co-ordinated every last detail of this complex undertaking; Jan Riley, Assistant Curator, who addressed the difficult task of securing loans; Carolyn Krause, Publications Co-ordinator, who helped with her editorial expertise; and Nancy Glier, Amy Banister and Jennifer Adams for their kindness and characteristic professionalism.

We are extremely fortunate to have received the support of many individuals and institutions in Britain. Deepest gratitude is due to Henry Meyric Hughes, Director, Fine Arts Department, the British Council; Nicholas Serota, Director of the Tate Gallery; Keith Hartley, Assistant Keeper, Scottish National Gallery of Modern Art; Sandy Moffat, teacher at the Glasgow School of Art; Greg Hilty of Riverside Studios; Iwona Blaszwick, Director of Exhibitions, the Institute of Contemporary Art; Andrew Brown and Victoria Keller of 369 Gallery, Edinburgh; and Maureen O. Paley, Mary Rose Beaumont, and Caryn Faure-Walker.

Our gratitude is also extended to the staffs of the galleries who helped us to locate paintings and secure loans. They are, in London: Jonathan Blond of Blond Fine Art; Sally Lescher and Isabel Norman of Conservation Management; Angela Flowers and Matthew Flowers of the Angela Flowers Gallery; Nigel Greenwood; Nicola Jacobs; Bernard Jacobson; Nicholas Logsdail of the Lisson Gallery; John Erle-Drax of Marlborough Fine Art; Graham Paton; Anthony Reynolds; Robin Page of the Benjamin Rhodes Gallery, and Edward Totah. We also wish to thank Barbara Toll and Jack Shainman in New York and Peter Goulds in Los Angeles.

We are indebted to the many private collectors and institutions who have given up their paintings to a two-year tour. We gratefully acknowledge not only their generosity but also the support they have given to these artists, exemplifying their commitment to this new work. We are also grateful to the artists for their participation. Special thanks go to Susan Kasen and Robert D. Summer of New York.

The exhibition was greatly enhanced by the publication of this catalogue by Phaidon Press, Oxford. Thanks are owed to all the staff at Phaidon who worked so diligently on the book. I enjoyed a valuable exchange of ideas with Judith Higgins, who contributed a sensitive and thoughtful essay to this publication.

I must thank my wonderful friends in London, in particular, Matthew Ford, Catherine Ford, Jessica Ford, Roger Vignoles and William Langley. I received encouragement and advice from my colleagues at the Fine Arts Department of the University of Pittsburgh, Professors Katheryn Linduff and Aaron Sheon. My friend David Resnicow was there, as always, to offer support in immeasurable ways. Finally, my deepest appreciation goes to my parents, whose love is my greatest inspiration.

Carolyn Cohen
Guest Curator

THE STORY OF BRITISH MODERNISM
Edward Lucie-Smith

The relationship between British twentieth-century art and the Modern Movement can be described in two different ways. In one version of the story, British painters and sculptors respond to innovations made abroad, lagging always a little behind the vanguard, and only succeed in achieving a kind of independence with the coming of Pop Art at the beginning of the 1960s. In another version, which seems to me more plausible, there was a continuous, though undeclared struggle between characteristics which could be described as purely national, and others, antipathetic to them, which were modernist. What now seem like the major artists of the first half of the century have surprisingly little in common with their European, and even their American contemporaries.

The first version owes much to a single influential critic. In November 1910, the first Post-Impressionist exhibition opened at the Grafton Galleries in London. The organizer was the Bloomsbury scholar and critic, Roger Fry, assisted by another Bloomsbury writer, Clive Bell. In October 1912 there was another Post-Impressionist exhibition in the same space, and Fry was again the prime mover. The two shows were the equivalent of the epoch-making Armory Show held in New York in February–March 1913. But they were more conservative in tone, and considerably less broadly based. Fry's hero was Cézanne, and he made him the foundation stone of a new approach to art. Both Fry and Bell had a strong hostility to the

achievements of the nineteenth century, and particularly to all aspects of the English Victorian epoch. They regarded the Britain of that era as irremediably pretentious, stuffy and moralistic, as indeed did all their Bloomsbury colleagues. The best known product of these attitudes is Lytton Strachey's book of mocking biographical essays, *Eminent Victorians*, published in 1918. Their hostility to the Victorians made Fry and his colleagues deeply unsympathetic to the achievements of British artists of that period.

Looked at from a less prejudiced standpoint, the nineteenth century seems to be the time when the visual arts in Britain were at their most inventive and fecund. At the beginning of the century, and then again at its end, they enjoyed widespread international influence. Constable had a profound impact on the French Romantics when his *View on the Stour* and *The Haywain* (Pl. 2) were shown at the Paris Salon of 1824. The late Pre-Raphaelites, Edward Burne-Jones (Pl. 4) and after him Aubrey Beardsley, influenced the European Symbolist Movement. Both made a contribution to the Blue Period paintings of the young Picasso, and Beardsley, in particular, was admired and imitated everywhere from Barcelona to St Petersburg. Even those British artists who had no immediate impact abroad have subsequently been recognized for their outstanding quality. John Ruskin (1819–1900), Fry's predecessor as the leading critic

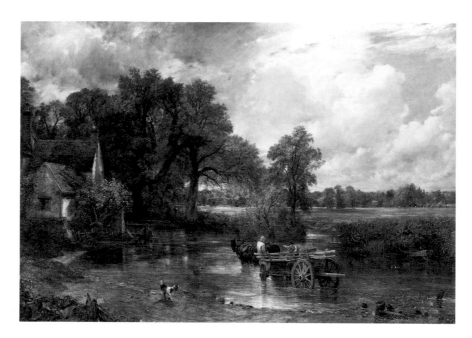

2 John Constable.
The Haywain. 1821.
Oil on canvas,
$51\frac{1}{4} \times 73$ in
(130×185 cm).
National Gallery,
London

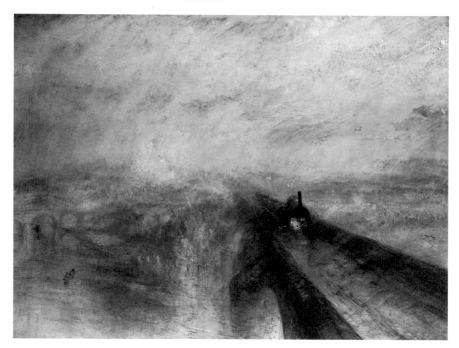

3 Joseph Mallord
William Turner.
*Rain, Steam and
Speed.* 1844. Oil on
canvas, $35\frac{3}{4} \times 48$ in
(91×122 cm).
National Gallery,
London

of the day, singled out first Turner then the Pre-Raphaelites. His belief was that they fulfilled the chief task of the visual artist, by celebrating the wonders of the world which was God's creation. Additionally, Ruskin was a nationalist—in his own words, he regarded the condition of the arts in England as a 'visible sign of national virtue'.

These were the attitudes Fry set himself to oppose. For him, Cézanne was the measure of everything that was lacking in British art. The kind of art Ruskin supported was an art which looked outward, beyond itself, and which only seemed to be moving and convincing if the spectator was willing and able to bring a full range of ideas and experiences to bear on its elucidation. J.M.W. Turner sometimes relied on the resonances of classical myth, but also sometimes on the feelings of excitement and unease generated by the Industrial Revolution (Pl. 3). The Pre-Raphaelites were, from the beginning, literary painters interested in narrative. Many of their most typical works are illustrations to Shakespeare's plays, to Keats, and to Tennyson.

Fry, like his contemporary and colleague Bernard Berenson, was keenly aware of the breakdown of traditional cultural values which was taking place in his time and, in particular, of the way in which the system of reference once available to all educated men had fragmented and become incoherent. Suddenly it was no longer safe to assume that everybody who was educated would recognize allusions to classical myth, ancient history and the Old and New Testaments. Berenson was able to rehabilitate the Italian Old Master paintings he studied with such passion by directing the audience's attention away from subject matter, and towards what he called 'tactile values'—that is, he encouraged the spectator to make a detailed analysis of the relationship of shapes, colour and texture in a particular painting. Each work of art thus became a closed self-referential universe—everything needed for an understanding of the artist's intentions was to be found in the picture itself.

Fry considered Cézanne's art to be the paradigm of such an approach, and a model for twentieth-century artists to follow. He discounted anything which seemed to call for a different way of looking at paintings. Since this clearly included nearly all of the British

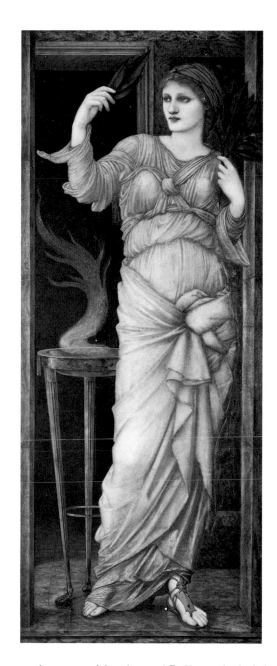

4 Edward Burne-Jones. *Sybilla Delphica. c.*1886. Oil on board, 60⅛ × 23¾ in (152.7 × 60.3 cm). City Art Gallery, Manchester

art known to him, he and Bell concluded that the British school was irremediably second-rate. Early in 1920, on his return from a visit to Paris, Bell used a sporting metaphor to drive the point home. 'In old racing days,' he wrote, '...it used to be held that French form was about seven pounds below English: the winner of the Derby, that is to say, could generally give the best French colt about that weight and a beating. In painting, English form is normally a stone below French. At any given moment the best painter in England is unlikely to be better than a first-rate man in the French second class.'

The denizens of Bloomsbury were no-

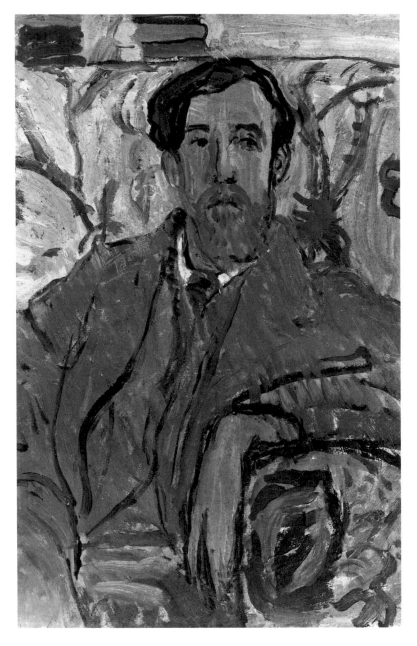

construct a history of British modernism which includes artists who were certainly more distinguished than these. Such a history is, nevertheless, a tale of disappointed hopes. It makes it seem as if the British were not really cut out to be fully fledged modernists. The most important avant-garde art movement in England in the years before World War I was undoubtedly Vorticism. Founded in October 1913, this movement established links with the Italian Futurists, and received direct personal encouragement from the man with the best claim to be called Futurism's creator, the poet and polemicist F.T. Marinetti. The word 'Vorticism' was coined by the poet Ezra Pound to suggest a whirling centripetal force which would draw together and concentrate avant-garde energies, but the movement itself was confused and eclectic. Its apologist and chronicler Richard Cork speaks of it as being 'poised half-way between the kinetic dynamics of Futurism and the static monumentality of Cubism, and rejecting French preference for domestic studio motifs as firmly as it replaced the Italians' rapturous worship of mechanical imagery with a more detached classical approach.' In fact much of its impetus was purely negative, and sprang from the antipathy which its leading figure, Wyndham Lewis (Pl. 8), felt for Fry and other members of the visual arts establishment. The Vorticists issued two numbers of an important magazine, appropriately entitled *Blast*, and a Vorticist Exhibition was held in London in 1915. By the time a similar exhibition was held in New York in January 1917, the movement itself was already dead.

In the years immediately following World War I, British art went through a very conservative phase. There was more than one reason for this. The economic situation in England was depressed long before the coming of the Slump. By the end of the war in 1918, purchasing power had drastically diminished from what it had been only four years previously. Additionally, the war had administered a grave psychological shock to the nation, and the mood among both patrons and artists was reserved and introspective. There was a somewhat similar mood in France, but there Modernism was already so firmly established that it led simply to a modulation of style—the experiments with classicism made by Picasso and

toriously clannish, and the painters whom Fry promoted most vigorously were close friends. The two most important were Vanessa Bell (Pl. 5) and Duncan Grant. It was typical of the intricacy of Bloomsbury relationships that Vanessa Bell, who was Virginia Woolf's sister and Clive Bell's wife, also became successively the mistress of Fry himself and of Grant. It was equally typical of Bloomsbury that Bell, who was equally concerned with pushing their interests, should implicitly have acknowledged that they were mediocre.

Using the two Post-Impressionist exhibitions as a starting point, it is possible to

5 Vanessa Bell. *Lytton Strachey*. *c*.1912. Oil on board, 14 × 10 in (35.6 × 25.4 cm). Anthony d'Offay Gallery, London

6 Ben Nicholson.
White Relief. 1935.
Oil on wood,
$40 \times 65\frac{1}{2}$ in
(101.6 × 166.4 cm).
Tate Gallery, London

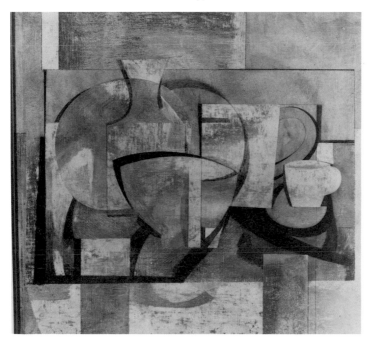

7 Ben Nicholson.
*Still Life (Greek
Landscape)*.
1931–6. Oil and
pencil on canvas,
$27 \times 30\frac{1}{2}$ in
(68.5 × 77.5 cm).
The British Council

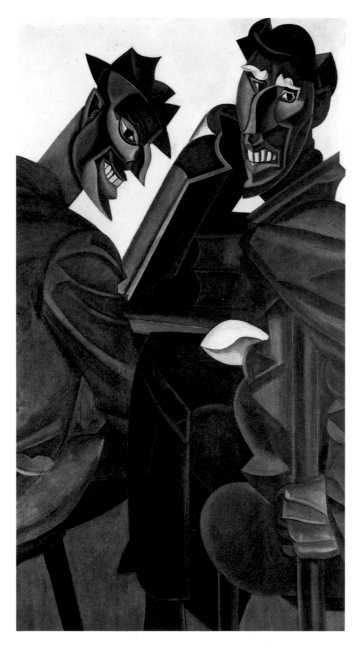

Derain, for example—and not to a complete abandonment of modernist principles. In Weimar Germany the mood was different again. Here the social structure had collapsed completely, and it was necessary to reconstruct it from the grass roots up. The result was a series of radical artistic experiments made in the very midst of desperate economic, political and social troubles, which turned Germany into the new centre of innovation in Europe. Yet in the 1920s British artists and intellectuals knew little and cared less about what was going on there.

In the early 1930s the modernist spirit

8 Percy Wyndham Lewis. *The Reading of Ovid*. 1920–1. Oil on canvas, 65 × 35 in (165 × 89 cm). Scottish National Gallery of Modern Art, Edinburgh

began at long last to revive in Britain. Some of the artists connected with this development had been involved with the Vorticists' ill-fated attempt to create an avant-garde on the continental model. One was Edward Wadsworth (1889–1949), whom Fry had included in the Second Post-Impressionist Exhibition and who a little later became one of the founder-members of the Vorticist Group. But the majority were newcomers. Among them were the two men who are now generally considered to be the true creators of a modernist tradition in British art—Ben Nicholson (1894–1982) and Henry Moore (1898–1986). Nicholson is the easier to equate with European tendencies. From 1924 he was a member of the Seven and Five Society, a small exhibitors' group which struggled to keep some sort of avant-garde activity going in London during the 1920s. In 1932 he went to France with Barbara Hepworth (1903–75), whom he was later to marry, and they came into direct contact with leading members of the School of Paris, among them Picasso, Braque, Brancusi and Arp. They became members of Abstraction-Création, an association which was the focus for Constructivist activity in Paris— Nicholson's abstract all-white reliefs (Pl. 6), first exhibited in 1934, were to be the chief contribution to this movement made by a British artist.

But Nicholson was never solely a Constructivist, any more than he was a pioneer of Constructivism except in strictly British terms. His work, though always marked by a characteristic spareness and purity, covers a wide stylistic range. He was attracted to Cubism and painted still lifes in a manner which owes much to Braque's personal development of the style (Pl. 7); and he also produced landscapes which show the influence of the Cornish naive painter Alfred Wallis (1855–1942), a retired fisherman whose work Nicholson discovered on a visit to St Ives.

Moore fits even less comfortably into European patterns of development, though his work, during the 1930s, was often loosely equated with Surrealism. In rebellion against the academic practices of the nineteenth century, his early sculpture was the product of direct carving in stone or in wood. In adopting this technique he was following in the footsteps of Brancusi and of the

16

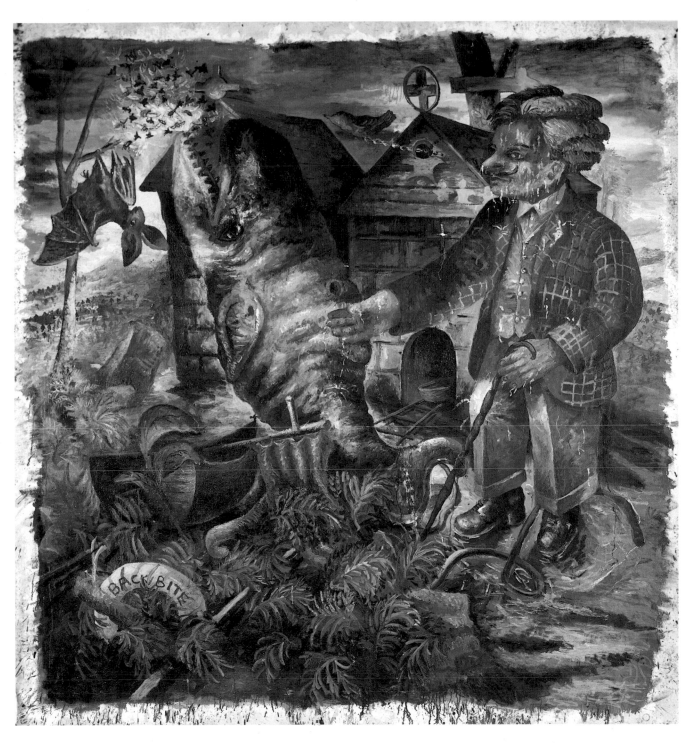

9 Steven Campbell.
*A Salty Tale : In a
Drought a Man Saves
a Whale by his
Perspiration and
Tears.* 1985

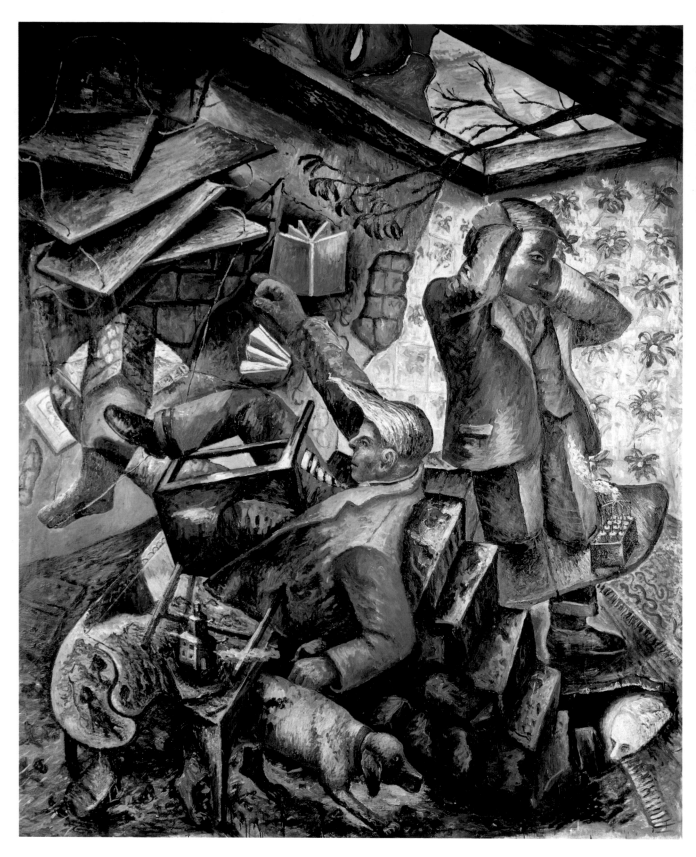

10 Steven Campbell.
*'Twas once an
Architect's Office in
Wee Nook.* 1984

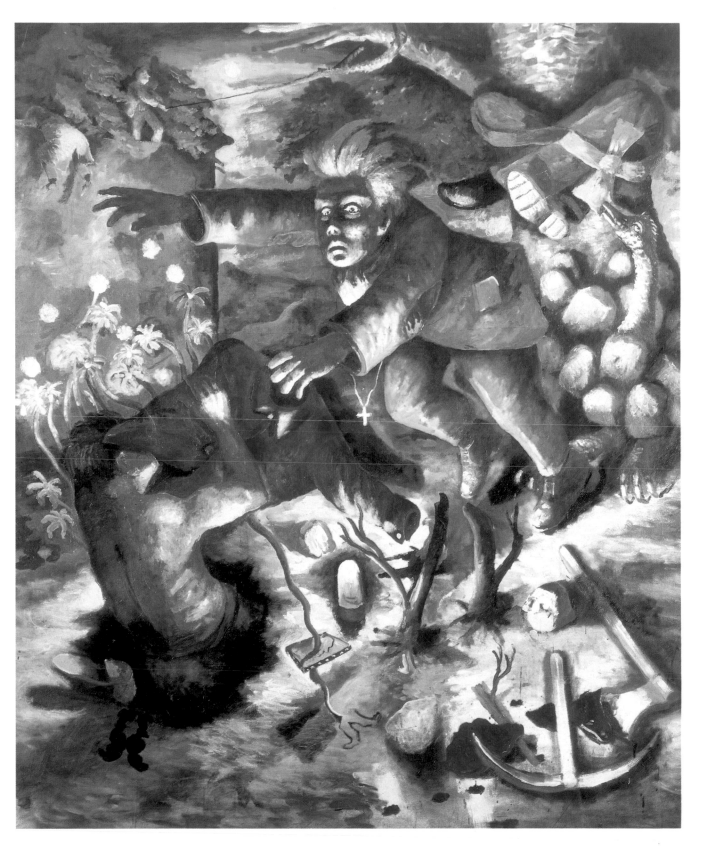

11 Steven Campbell.
The Man who Gave
his Legs to God and
God Did not Want
them. 1987

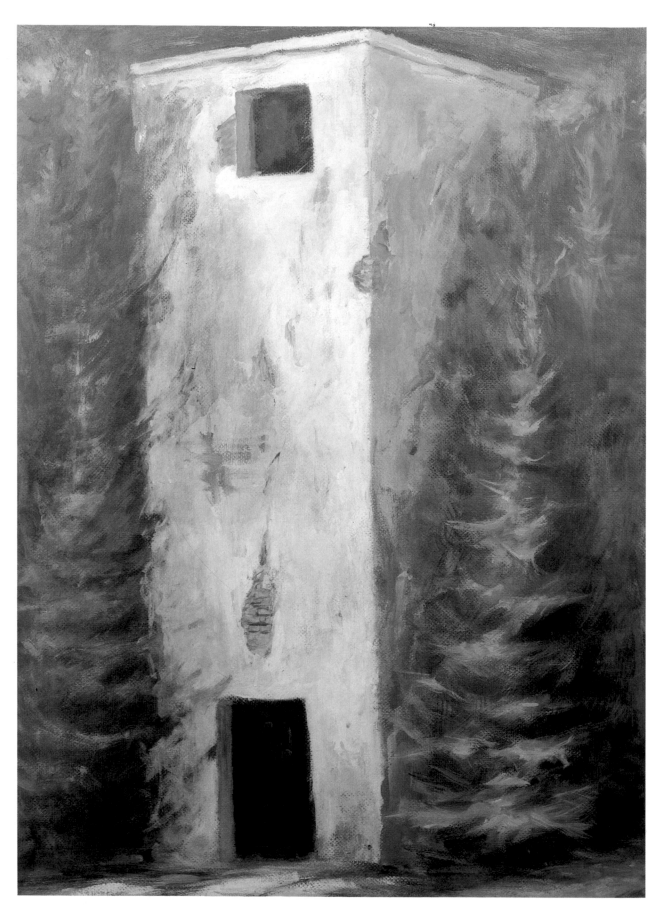

12 Stephen Barclay.
Night Tower. 1987

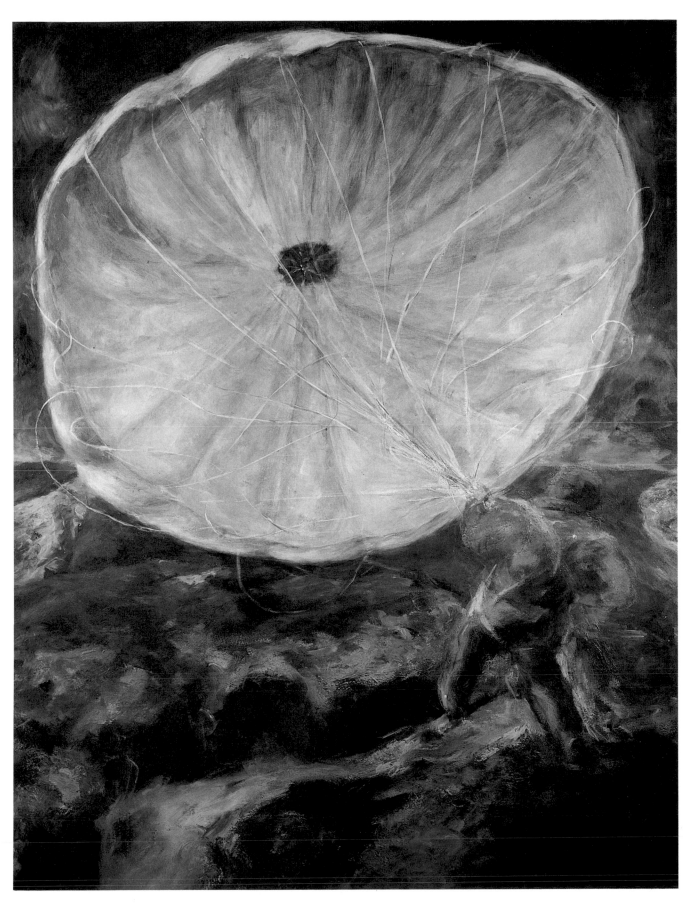

13 Stephen Barclay.
The Parachutist.
1986

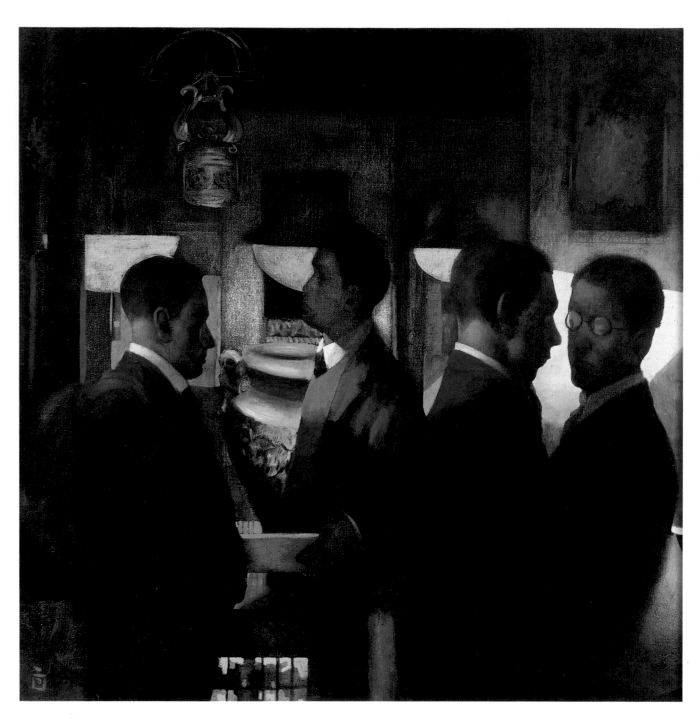

14 Stephen Conroy.
167 Renfrew Street.
1986

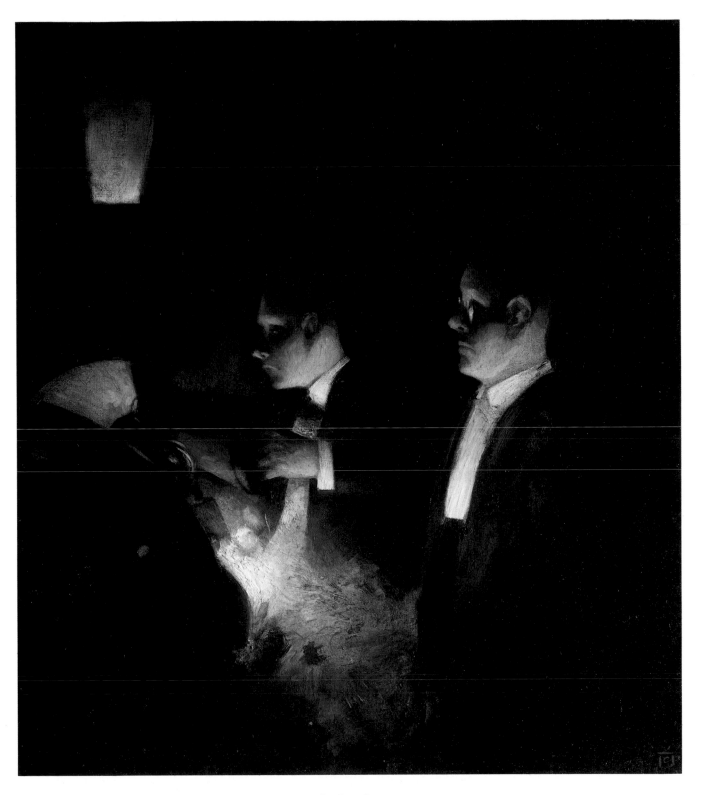

15 Stephen Conroy.
Wireless Vision
Accomplished. 1987

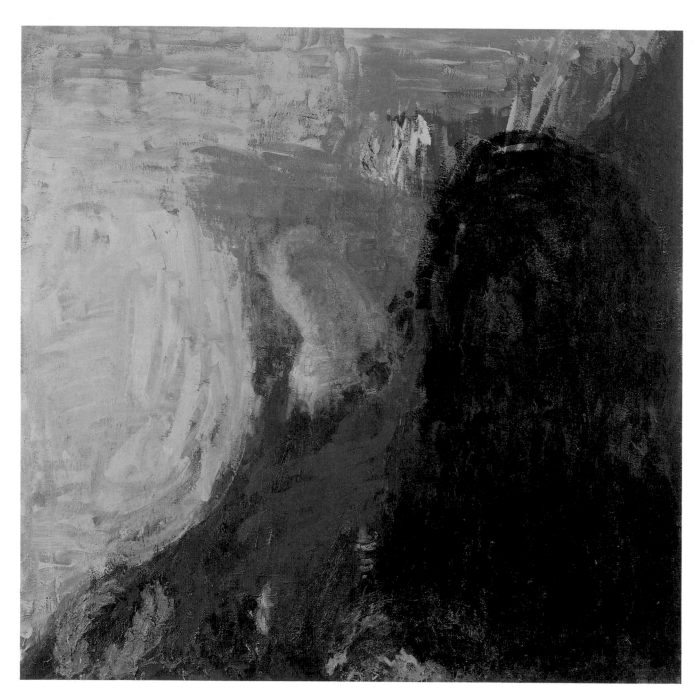

16 Christopher Le Brun.
Wake. 1984

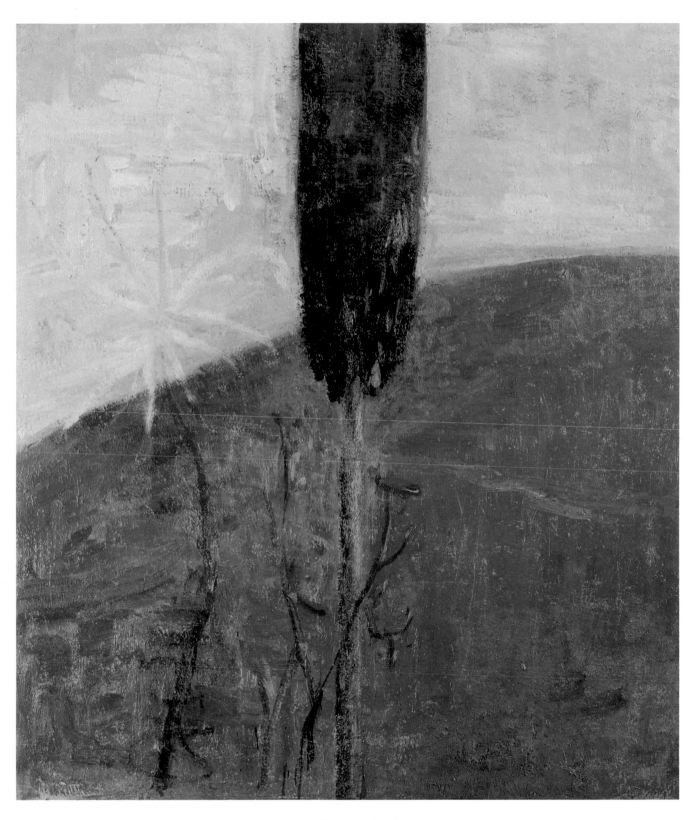

17 Christopher Le Brun.
Tree with Hill. 1987

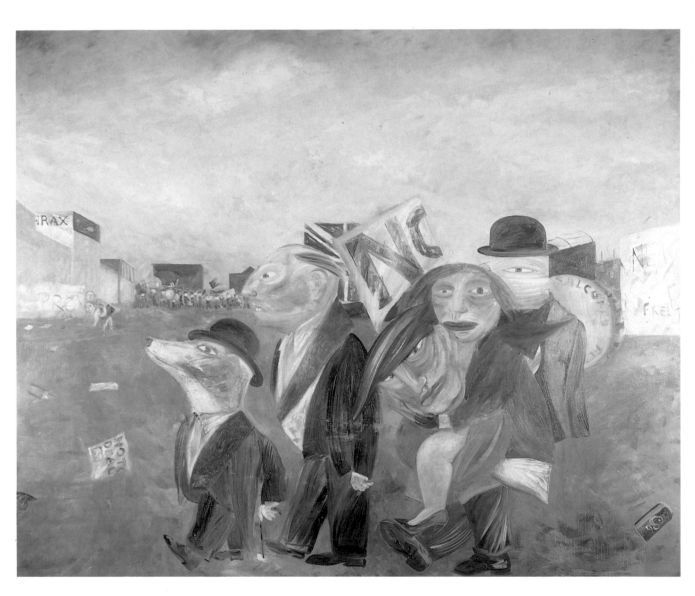

18 Jock McFadyen.
Parade. 1986

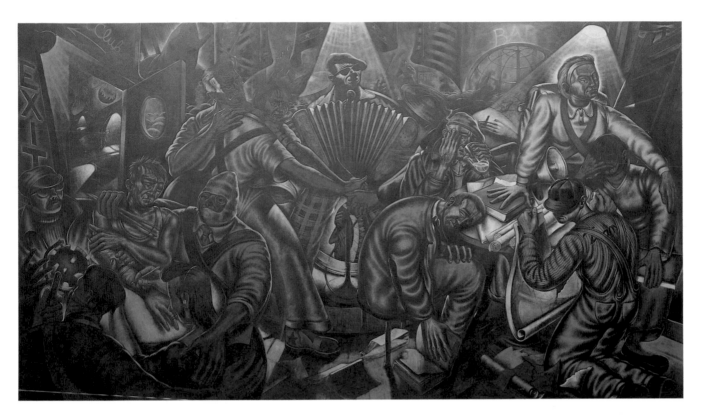

19 Ken Currie.
In the City Bar. 1987

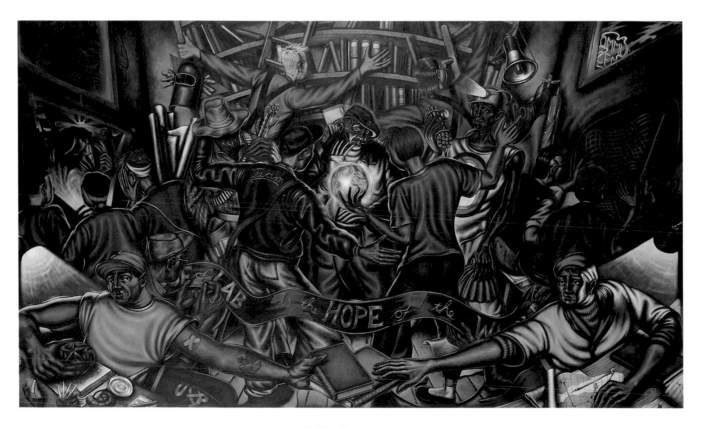

20 Ken Currie.
*Workshop of the
World (Hope and
Optimism in Spite of
Present Difficulties).*
1987

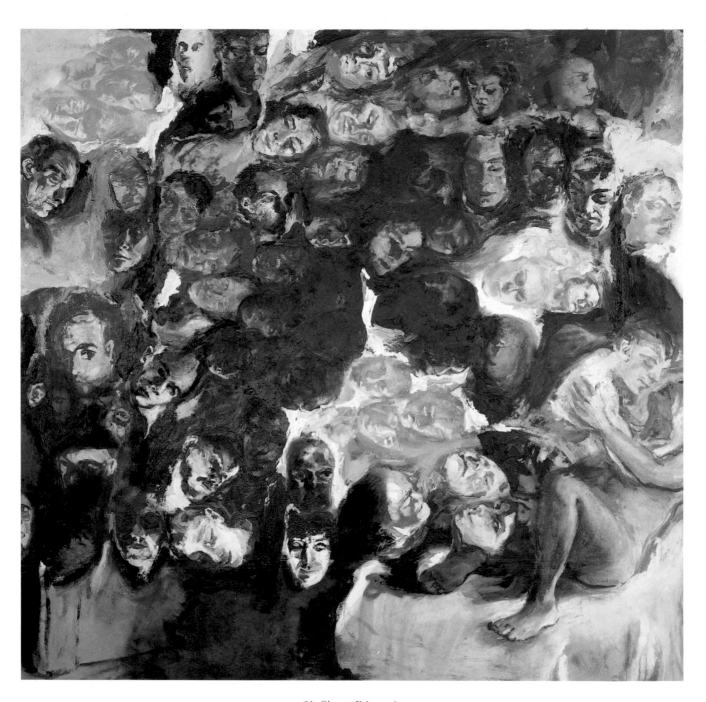

21 Simon Edmondson.
*A Hundred Ardent
Lovers Fell into
Eternal Sleep.* 1987

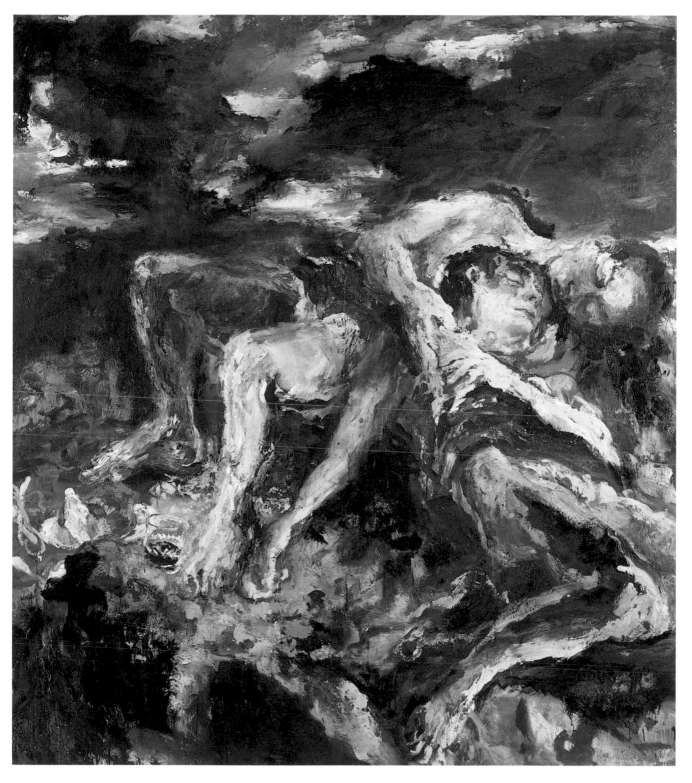

22 Simon Edmondson.
Elements. 1986

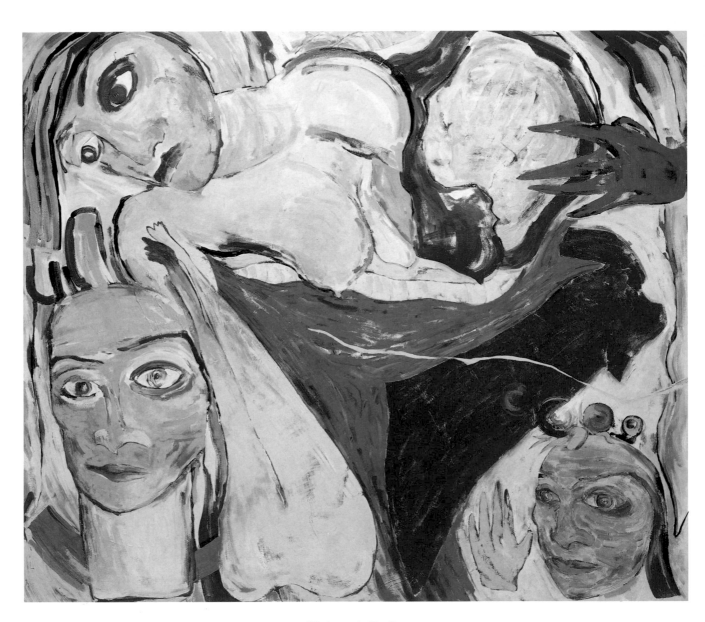

23 Amanda Faulkner.
Dirty Faces. 1987

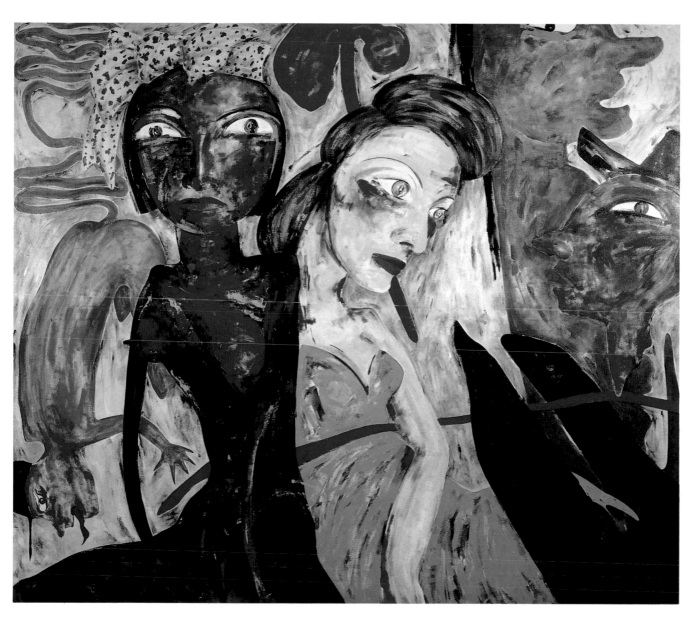

24 Amanda Faulkner.
Inside Out. 1985

25 Gwen Hardie.
The Brave One. 1987

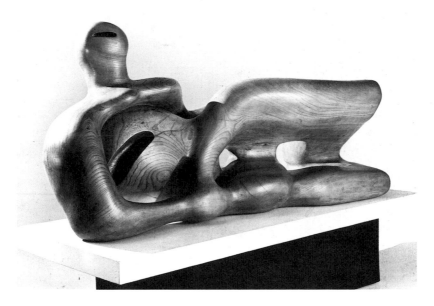

Anglo-American sculptor Jacob Epstein (1880–1959), who was one of the first to praise Moore's work. His chief stylistic influences came, not from contemporary art, but from that produced by ancient and primitive cultures—Ancient Egyptian, Archaic Greek, and, in particular, the stone-carvings of Pre-Columbian America. From the Aztec *chacmool*, a kind of reclining figure used as an offering-table, he evolved his own reclining figures, which became a metaphor for landscape (Pl. 26). This theme was one which he continued to develop throughout his long career.

Moore's fixation on the art of the remote past and his attitude to landscape were an inheritance from the Romantic Movement of the nineteenth century. He was not the only artist who continued to respond to the Romantic impulse. A particularly strong spell was cast by the tiny Shoreham-period landscapes of Samuel Palmer (1805–81) (Pl. 29), the disciple of William Blake. One artist who responded strongly to them was Paul Nash (1889–1946), now increasingly seen as one of the most important British artists of the inter-war period. Nash began as a belated Pre-Raphaelite and developed enormously as the result of his experiences at the front during World War I and the commissions he received as an Official War Artist (Pl. 27). In the 1930s he showed that his romantic, visionary approach to landscape was easily compatible with certain aspects of Surrealism (Pl. 28). Graham Sutherland

26 Henry Moore. *Reclining Figure.* 1945–6. Elmwood, length 75 in (190.5 cm).

(1903–80) remains a more controversial figure. In the 1920s, when he was working as a printmaker, his dependence on Palmer was slavish. After the collapse of the print collecting boom at the end of the decade he turned to painting, and produced metamorphic interpretations of Pembrokeshire landscape which, like Nash's work at the same period, have a distinctly Surrealist tinge (Pl. 30). Later still, after World War II, he was to make a much-contested reputation as a painter of celebrities such as Somerset Maugham and Helena Rubinstein.

Towards the end of the 1930s, there was an attempt to create an orthodox Surrealist Group in Britain. A large International Surrealist Exhibition was held in London in 1936, which included a respectable number of British artists, among them Moore, Nash and Sutherland. But these, who were among the best known, never felt comfortable with Surrealist orthodoxy, and Surrealism in Britain was soon reduced to a rump. The persistence of the survivors was not equalled by their talent, and those artists who remained closely allied to the movement in its European form have not enjoyed much respect from later chroniclers of the British scene. Significantly, none of the core group of British Surrealists was included in the Royal Academy's *British Art in the 20th Century: The Modern Movement* shown at Burlington House in January–April 1987, which is the most ambitious survey of its subject yet to have been organized.

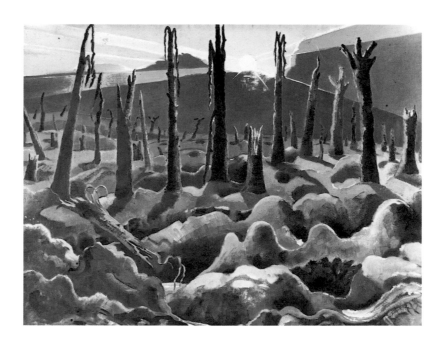

27 Paul Nash.
*We Are Making a
New World*. 1918.
Oil on canvas,
28 × 36 in
(71.1 × 91.4 cm).
Imperial War
Museum, London

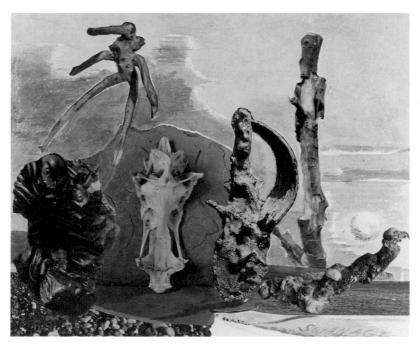

28 Paul Nash.
*Swanage. c.*1936.
Photography,
drawing and
watercolour,
$15\frac{3}{4} \times 22\frac{7}{8}$ in
(40 × 58 cm). Tate
Gallery, London

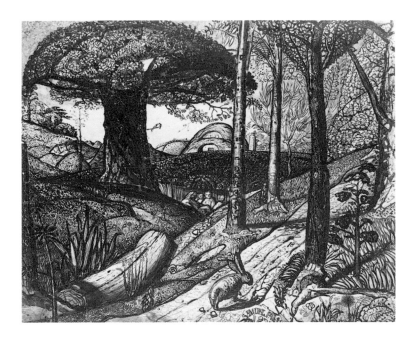

29 Samuel Palmer.
Early Morning. 1825.
Pen and wash and
brown ink with
gum, $7\frac{3}{4} \times 9\frac{1}{8}$ in
(19.7 × 23.2 cm).
Ashmolean
Museum, Oxford

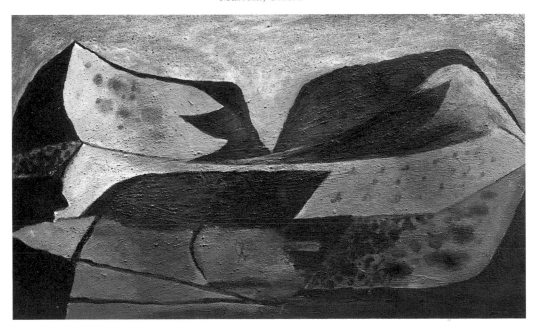

30 Graham Sutherland.
Welsh Mountains. 1937.
Oil on canvas,
22 × 36 in
(55.9 × 91.4 cm).
Art Gallery of New
South Wales, Sydney

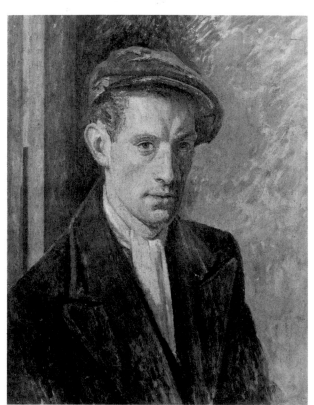 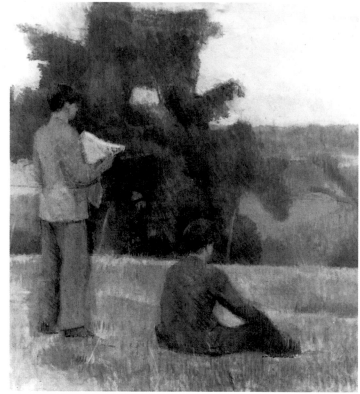

31 Percy Horton.
Unemployed Man.
*c.*1936. Oil on
plywood,
$17\frac{1}{2} \times 14$ in
(44.5 × 35.6 cm).
Sheffield Art
Galleries

32 William Coldstream.
On the Map. 1937.
Oil on canvas,
20 × 20 in
(50.3 × 50.3 cm).
Anthony d'Offay
Gallery, London

The 1930s were a highly political decade in Britain, just as they were elsewhere. The Surrealists tried to ally themselves to another group, organized on very different principles—the Artists' International Association, founded in 1933. The inspiration for this group came from Soviet Russia, and a 'First Statement of Aims' published in the periodical *International Literature* in 1934 chronicled the Association's activities up to that point:

> We have instituted fortnightly discussions on Communism and Art from all angles. We are working closely with the Marx Library and the Workers' School. We have taken part in strikes and elections, producing mimeographed newspapers on the spot, backed up by cartoons and posters. This will give us the direct experience we need of contact with the masses.

The AIA was able to draw to itself artists who were better known in other contexts. Even Vanessa Bell and Duncan Grant played a marginal part in its activities, prompted by sympathy for the Republican cause in the Spanish Civil War. More central to the group, and more typical in style, were a number of English Social Realists such as Cliff Rowe, the brothers Ronald and Percy Horton (Pl. 31), and Clive Branson. They have been forgotten even more completely than the minor British Surrealists of the time, and there is now considerable difficulty in seeing examples of their work.

One group of Social Realists from the late 1930s is better remembered—the Euston Road School, founded in 1937 under the leadership of William Coldstream (1908–87). Coldstream arrived at realism for much the same reasons as the founders of the AIA: 'The Slump', he said later, 'had made me aware of social problems, and I became convinced that art ought to be directed towards a wider public. Whereas all the ideas I had learned to be artistically revolutionary ran in the opposite direction. Public art must mean realism.' In early works, such as *On the Map* (Pl. 32), he spices this realism with ambiguously conspiratorial imagery which perhaps owes something to the contemporary poems and plays of W.H. Auden.

Coldstream held other equally firm con-

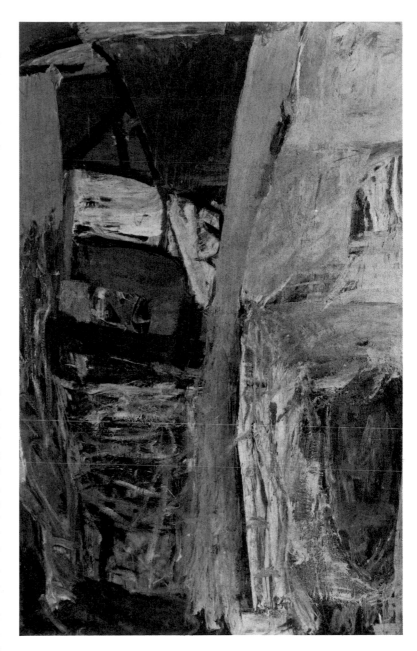

33 Peter Lanyon. *Sandbar*. 1956. Oil on canvas, 72 × 48 in (182 × 121 cm). Private collection

victions about the way in which paintings should actually be made. His pupil Lawrence Gowing encapsulates in a phrase Euston Road attitudes to technique when he remarks that the members of the group 'opposed to the aesthetics of discrimination an aesthetic of verification'. Coldstream's laborious way of constructing paintings was imparted to several generations of British artists. Many of his disciples are still actively at work today, and it was essentially their approach which was explored in an exhibition entitled *The Hard-Won Image*, organized by the Tate Gallery, London, in 1984.

Subsequent developments, being better

37

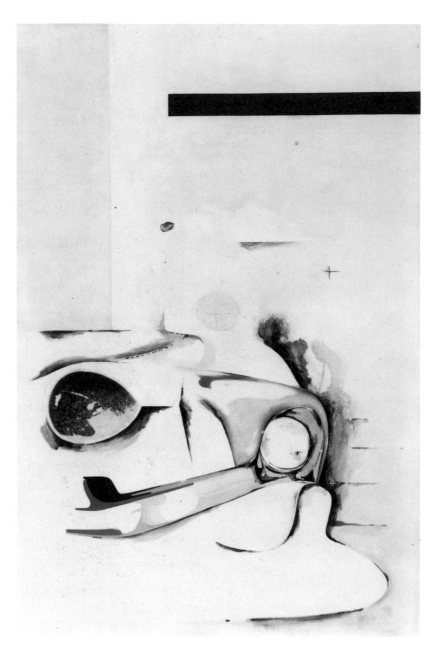

artworld had shifted from Paris to New York, and after an initial moment of resistance the compass of British art began to swing in that direction. The post-war St Ives School, typified by Peter Lanyon (1918–60) tried to reconcile the subjectivity and the free brushwork of American Abstract Expressionism with a traditional British interest in landscape (Pl. 33); the London-based Situation Group (founded in 1960) were influenced by American Post-Painterly Abstractionists such as Morris Louis and Kenneth Noland.

British Pop Art has a much greater claim to be considered an independent and original style than the British abstraction of the same period. The British people, struggling with the restrictions and difficulties of the austere post-war period, viewed American urban mass-culture as something both alluring and altogether exotic. Richard Hamilton, whose 1956 collage *Just what Is it Makes Today's Homes so Different, so Appealing?* is generally recognized to be the first example of Pop Art to be made anywhere, filtered his fascination with the images of mass-culture through a sieve of Duchampian irony (Pl. 34). The resulting works had a conscious refinement and elegance quite foreign to the American Pop Art which emerged some four years later.

During the 1960s British Pop continued to deviate widely from the established American model. Narrative was a conspicuous element in the early work of David Hockney, who looked back to Hogarth in a series of prints inspired by *The Rake's Progress*. It was also important to Peter Blake. Blake's work abounds in romantic nostalgia, and much of what he has produced (for example, the paintings of fairies and the illustrations to *Alice in Wonderland*) returns to nineteenth-century sources. Another source of nostalgia is the popular culture of Blake's own youth, as exemplified in the series devoted to wrestlers (Pl. 35). During the 1970s, which on the whole was a stagnant period for British painting as opposed to British sculpture, Blake took part in a surprising new initiative. With the foundation of the Brotherhood of Ruralists (1975) in which he was the chief figure, Blake affirmed his allegiance to Samuel Palmer and also to Palmer's Pre-Raphaelite successors.

The account given above, in treating the

known, can be summarized more rapidly. The Social Realism of the late 1930s was followed by the Neo-Romanticism which flourished in Britain during the war, and which is typified by John Piper's romantic drawings of architecture. The style was essentially an insular, self-protective reaction against world events. It was followed by an attempt to revive Social Realism in a more passionate and Expressionist guise—the so-called Kitchen Sink School (Jack Smith, John Bratby and others), received vehement support from Marxist critics such as John Berger. But it was already becoming apparent that the capital of the international

34 Richard Hamilton. *Hommage à Chrysler Corp.* 1957. Oil, metal foil and collage on panel, 48 × 32 in (122 × 81.2 cm). Tate Gallery, London

development of British art in terms of successive 'movements', follows one of the most deep-rooted conventions of modernist art history. In fact, it is impossible to understand the development of British painting in the twentieth century without looking at the contribution made by certain individuals, all deeply resistant to categorization. Four artists who seem to me of major importance for understanding British art in the 1980s are Stanley Spencer (1891–1959), David Bomberg (1890–1957), Francis Bacon (b.1909) and Lucian Freud (b.1922).

Spencer and Bomberg were fellow students at the Slade School of Art in London before World War I. Spencer was chosen by Fry for the Second Post-Impressionist Exhibition. But despite membership of the New English Art Club (1919–27) and of the Royal Academy (elected in 1932, he resigned in 1935 and rejoined in 1950), he proved completely unassimilable to any art movement. In one sense, his horizons were extraordinarily narrow. Born in the village of Cookham, on the Thames in Berkshire, he remained obsessed by his childhood there and it remained the setting for much of his work. Spencer was deeply if idiosyncratically religious. He perceived Cookham as the natural setting for visionary events and frequently depicted episodes of the New Testament story situated in his native spot. Even works which are not overtly religious, such as *The Dustmen* (Pl. 36), are mystical celebrations of everyday occurrences. His powerful interpretation of religious themes, to which he also brought a strong sexuality, makes his work the closest twentieth-century comparison with that of William Blake. At the same time, his abounding skills as a draughtsman, the quirkiness of his approach to everyday reality, and the egoism which made him see everything in a personal focus, all suggest a likeness to a later self-mythologizer—David Hockney.

Bomberg is an even stranger case. He, like Spencer, enjoyed considerable success as a student at the Slade. He became involved very early with the embryonic pre-war avant-garde (Pl. 38), went to Paris in 1913 in the company of Jacob Epstein (where he met Picasso, Derain and Modigliani) and held a one-man show in London in July 1914 which was visited by Marinetti. During this period Bomberg was associated with the Vorticists,

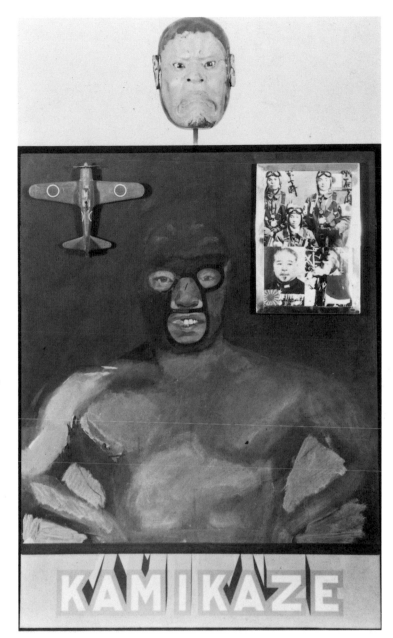

35 Peter Blake. *Kamikaze*. 1965. Cryla, collage on hardboard, 31 × 18¾ in (78.7 × 47.6 cm). Private collection

but never completely threw in his lot with them. After the war his fortunes changed, and he became a neglected outsider. This was partly due to the collapse of patronage in the post-war Slump, but it owed more to his own change of style and his prolonged absences abroad. Some of the work he produced was ploddingly topographical, but most was in a new manner using heavy brushstrokes and thick paint (Pl. 37), akin to pre-war German Expressionism but without the fierce spontaneity associated with the style. To those in thrall to the School of Paris, such as Fry and Bell, Bomberg's work seemed dour and abrasive—as dour and abrasive as

39

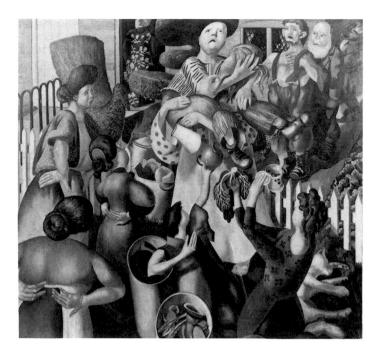

36 Stanley Spencer.
The Dustmen or
The Lovers. 1934.
Oil on canvas,
45¼ × 45¼ in
(115 × 115 cm).
Laing Art Gallery,
Newcastle upon Tyne

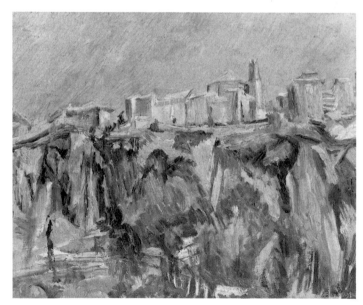

37 David Bomberg.
Cuenca Facing West.
1934. Oil on board,
20 × 24 in
(51 × 61 cm).
Private collection

his occasional petitions to those who might be in a position to help him.

During World War II, Bomberg, with immense difficulty, obtained a little work as an Official War Artist. Confined to Britain, he also began to teach part-time. From 1945 to 1953 he taught at the Borough Polytechnic in East London. His pupils there included Frank Auerbach (b.1931) and Leon Kossoff (b.1926), both now widely recognized as leading artists and the best exponents of a style which has been described as 'slow Expressionism', still deeply rooted in Bomberg's work. Bomberg himself never received the acclaim he knew was his due. The retrospective exhibition *Wyndham Lewis and the Vorticists*, held at the Tate Gallery in 1956, played down Bomberg's contribution and represented the movement as being essentially Lewis's personal creation. The injustice of this preyed on Bomberg's mind, and contributed to his death in 1957. The great Bomberg retrospective at the Tate Gallery in 1988 was a long overdue reparation.

Bacon has perhaps suffered from too much rather than too little acclaim. From his first thunderous appearance on the London art-scene, just after World War II, he has attracted numerous imitators but has had no direct descendants and certainly no pupils. Critics have often been exercised to define what sort of painter he is—one popular theory has it that he represents a kind of existentialist extension of Surrealism. In

38 David Bomberg.
The Mud Bath.
1912–13.
Oil on canvas,
69 × 88¼ in
(175.3 × 224.1 cm).
Tate Gallery,
London

fact, Bacon seems to me a striking example of the survival of Romanticism in British art. The American critic Robert Rosenblum, in a catalogue essay for the Royal Academy's *British Art in the 20th Century*, perceptively compared him to Füseli. The comparison points up very exactly Bacon's mixture of the sublime, the excessive, the outrageous and the slightly ridiculous (Pl. 39).

Lucian Freud, the grandson of Sigmund Freud, was born in Berlin and was brought to Britain in 1932 as a refugee from the gathering menace of Nazism. Freud paints in a style which seems like a continuation of the *Neue Sachlichkeit* (New Objectivity) of the Weimar Republic—his work suggests comparisons with that of Georg Grosz and Otto Dix, and also with that of German Magic Realists such as Christian Schad (Pl. 40). Like these German predecessors, his painting mingles Expressionist and Realist elements—the image conforms to established Realist norms, but is the vehicle for a subjective intensity of feeling that evokes the adjective Expressionist.

No-one can deny that the four painters described occupy a very distinguished place in the history of British painting during this century. In the circumstances, it is striking how far all of them seem to deviate from the ideal model for modernist art originally proposed by Roger Fry. All of them put some emphasis on the importance of subject-matter: none makes compositions which are self-referential and self-sufficient in a Cézannian way, though Bomberg perhaps

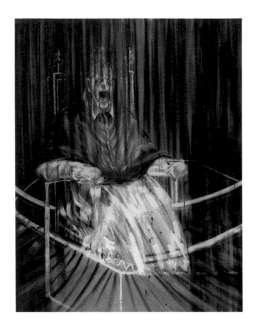

comes closest to it.

A recent attempt has been made to tidy up the history of British Modernism, while at the same time returning it to the neat dialectic of one art movement answering another, by proposing that we now speak of a School of London, as an analogue to the old School of Paris of the period before and after World War I. Some of its presumed members have already been mentioned—Bacon, Freud, Auerbach and Kossoff. Other proposed members are Howard Hodgkin (b.1932) and the British-domiciled American, R. B. Kitaj (b.1932). While these artists are too different from one another, and in some cases also too widely separated in age, to make a convincing group, it cannot be denied that they are indeed the natural predecessors of the artists included in the present exhibition. And these younger artists, too, offer a sharp rejection of Fry's definition of Modernism.

If one looks at the work chosen for the present show, one notices, despite wide differences of style between the artists themselves, a strong emphasis on content, as well as other close links with the British art of the nineteenth century. The works included seem to me to fall into three overlapping categories: Romantic painting of landscape, usually with reference to either Turner (Ian McKeever, Thérèse Oulton or Christopher Le Brun), or Samuel Palmer (John Virtue); the elaboration of a personal mythology which is almost equally Romantic in tone, and which could perhaps be seen as descend-

39 Francis Bacon. *Study after Velazquez's Portrait of Pope Innocent X.* 1953. Oil on canvas, 66¼ × 46½ in (168.2 × 118.1 cm). Des Moines Art Center

ing both from Blake and from Pre-Raphaelites such as Dante Gabriel Rossetti and William Holman Hunt (Eileen Cooper, Steven Campbell, Andrzej Jackowski); and social commentary (Graham Cowley, Ken Currie, Peter Howson). This third theme, in particular, is worth a moment's consideration. It looks back most immediately not to the Victorian epoch but to the 1930s, and in particular to the almost-forgotten founders of the Artists' International Association. But it can also be referred to certain late Victorian artists who are now the subject of serious art-historical study, notably Luke Fildes (1844–1927) and Frank Holl (1845–88).

Some features of the show are novel, both in comparison with the Royal Academy's *British Art in the 20th Century*, and with the Tate Gallery's *The Hard-Won Image*. One of these is the comparatively high proportion of women artists—here seven out of twenty-six, compared to six out of seventy-two at the Royal Academy and three out of forty-five at the Tate. Another is the way in which Scottish art is fully integrated with what is happening south of the border. These shifts do more than right injustices, they give recognition to fundamental changes which have taken place in the British artworld during the last decade. *The Vigorous Imagination*, a survey of new Scottish art held at the Scottish National Gallery of Modern Art, Edinburgh, in 1987 made it plain that painting in Scotland is enjoying an outburst of energy unknown

42

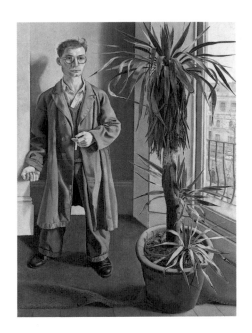

there since the early years of the century.

Most of all, however, the show is novel in that is proposes a new way of reading the whole development of British painting in the twentieth century, from the time of the Post-Impressionist Exhibitions onward. Not the least surprising aspect of this interpretation is

40 Lucian Freud.
Interior near Paddington. 1951.
Oil on canvas,
60 × 45 in
(152.4 × 114.3 cm).
Walker Art
Gallery, Liverpool

the way in which it runs counter to the shibboleths of Modernist Internationalism. It puts forward the idea that it is possible to see an important segment of contemporary art in national terms. The adjective 'British' here receives almost equal emphasis with the noun 'painting'.

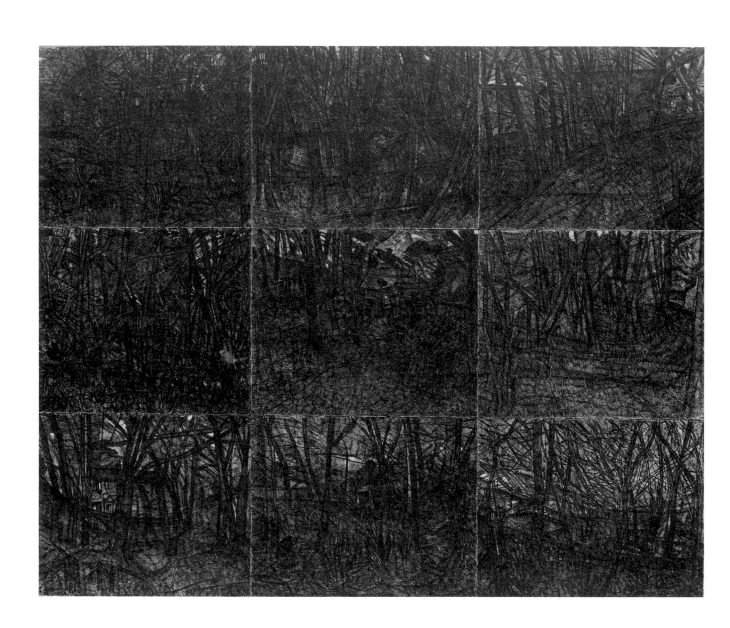

THE NEW BRITISH PAINTING
Carolyn Cohen

The decade of the 1980s has witnessed a burgeoning new vitality in British art. In a climate where the visual arts have never been held in the same esteem as literature, drama or music, the attention currently focused on painting and sculpture suggests that the visual arts are beginning to find an appreciative audience and, at a gradual but steady pace, gain their rightful status.

A number of factors in Britain account for this critical shift. Certainly, the opportunities for viewing art are increasing: commercial galleries and alternative spaces are proliferating, particularly in London, and many exhibitions have been organized and circulated throughout Britain. The emergence of Scotland as a centre of prodigious activity (demonstrated in the 1987 exhibition *The Vigorous Imagination: New Scottish Art* organized by the Scottish National Gallery of Modern Art), has broadened the scope of British art, and energized the London art market. Further evidence of interest and support is shown by the public who, after taking their lead from a few important collectors, seem willing to buy contemporary art. And a dedicated group of art critics continues to enliven the print and broadcast media and help to mitigate the customary tide of resistance to the visual arts.

This revitalization is very much a product of a new *Zeitgeist* of the 1980s. Having been for so long its own worst enemy, the British artworld is beginning to shed the vestiges of its inferiority complex. Undoubtedly, con-

Opposite:
41 John Virtue.
Landscape No. 28.
1985–6

temporary British artists have been a galvanizing force in the recovery of British confidence and national identity. For one thing, New York no longer serves British artists as their primary reference point, as it has in previous decades. Nor do these artists feel compelled to defend or qualify their position against an international background.

The artists in this exhibition share a common concern for humanism. Much of the work is, therefore, figurative. While it could be argued that the landscape painters tend toward abstraction, their imagery, nonetheless, remains rooted in natural forms. The most immediate source for British figurative painting in the 1980s is the 'School of London' (Francis Bacon, Lucian Freud, Leon Kossoff, Frank Auerbach, R.B. Kitaj and Michael Andrews), a group of artists who formed a nucleus of the Tate Gallery's 1984 exhibition, *The Hard-Won Image*.[1] Eschewing the abstraction of the 1950s, these artists struggled to sustain the continuity of the British figurative tradition in the midst of a hostile environment. In claiming the pre-eminence of these modern masters, *The Hard-Won Image* put forth a strong case for the return of figuration as one of the most important elements of contemporary British painting.

The common cultural identity of the new generation has nurtured an aesthetic which is 'issue-oriented', as well as figurative. These issues, while based on a personal vision, are often derived from broader cultural, social or

historical arenas. A curious feature of these artists is their tendency to search for appropriate models from the past to interpret ideas of the present. For example, ties to nineteenth-century British painting are apparent in their approach to the subject of landscape. But sources other than the British past are equally prevalent among these painters. It is less a characteristic of eclecticism and more a function of their academic training and access to important public collections, that accounts for their wealth of art historical references. Certain artists adopt the formal vocabularies of early twentieth-century movements, such as French Fauvism or German *Neue Sachlichkeit* (New Objectivity), into their imagery, while the classical tradition, as it survived into the late nineteenth century, is both revered and rigidly practised among younger artists.

Especially relevant in the context of this exhibition is the American response to contemporary British painting. The current wave of interest among the British in their new generation of painters was stimulated, in part, by enterprising American curators, dealers and collectors who, in the beginning of the 1980s, played *deus ex machina*. This intervention resulted in not only the representation of even the most risky work in important US collections and exhibitions; it also forced the British art world to take notice of its own bright stars. It is significant, for example, that Steven Campbell, who initiated the present activity and attention focused on Glasgow, established his reputation first in New York.

That the American interest has boosted the credibility of the new British painting in Britain is, perhaps, best perceived as an indication of the greater receptivity within the US (for better or worse) to new developments in contemporary art. The American appetite for new British painting, however, suggests that these works satisfy a certain longing for a content-based imagery. Ironically, Britain's insularity and previous lack of a supportive environment for its artists may account for the high degree of originality and integrity characteristic to its painting. This imagery seems to thrive on an innovation that is more evolutionary than exploratory. The work can be ingenuous and forthright without being simplistic. While it is often arcane, it is not remote and even at its most introspective it offers a connective thread to the outside world.

The New British Painting is an overview of British painting of the 1980s. By no means exhaustive or comprehensive, it is a preamble to a larger movement in progress. The twenty-six artists included in this exhibition all live and work primarily in Britain where they received their artistic training. They range in age from twenty-four to forty-two. Many of them, therefore, began their careers in the present decade. As a collective body they form a postscript to the 1987 exhibition, *British Art in the 20th Century*, organized by the Royal Academy of Arts, London. They are likely, however, to be remembered in surveys of art of the twenty-first century.

The artists selected for inclusion in the exhibition form no coherent group, nor do they represent any single direction. In the process of selection, however, certain similarities in their work, indicative of the predominant currents in contemporary British painting, became evident. The artists were chosen from among scores of immensely gifted and inventive painters because they synthesize, in our view, those characteristics which individuate their national identity. One such characteristic is the reinstatement of the importance of subject-matter, manifested in an overwhelming concern for humanism, expressed through a variety of ways. No less apparent, however, is the vigour with which they freely set forth their own ideas about the nature of painting.

Certain shared ideologies and subjects provide a framework for grouping these artists thematically. They are discussed, therefore, individually within four broad overlapping categories. These are: *Still Life*, *Landscape*, elaboration of *Personal Mythology* and *Social Concerns*.

Still Life

Both John Monks and Lisa Milroy are painters of objects extracted from the commonplace or familiar. These objects are dissociated from their original contexts, stripped of utility and function, and relocated into settings which alter their symbolic values. These artists share a somewhat abstractionist approach to content, although

their concerns are not entirely formal. They are highly innovative within a still-life tradition which, in the case of Monks and Milroy, seems too limited a category.

Monks' excavation sites are London's rubbish heaps, where he finds discarded bits of clothing, appliances or car parts. All of these things, created by and for human beings, had a former life. They are fashioned by the artist into *memento mori*, reminders of death. Objects are re-assigned to his studio, where Monks sets out to 'construct (for them) an environment, an atmosphere, some kind of mood or interior'.[2] The artist's presence is detected in the studied, classical order of his compositions and the infusion of artificial, theatrical lighting that adumbrates some forms and illuminates the rich textures of others. Although he describes his objects with painstaking precision, Monks skillfully manages to avoid preciosity (Pls. 51, 52).

By contrast, Milroy, who paints objects from memory, intentionally withholds clues about their original contexts or relocation. Her paintings convey a strong sense of detachment, as they are about things twice removed from experience. Milroy avoids consistency in perspective, and the neutral space which contains her objects could be an imaginary wall or a floor. A subtle, homogenous source of light provides the whispered tonalities that illusionistically describe the volume of her objects. Milroy looks at things as representations of a class or species, defined by appearance rather than essence. In *Fragments* (Pl. 42), she depicts individual pieces of Greek pottery, set apart from one another. The artist's fascination with regimentation is denoted in *Shirts* (Pl. 44), where she repeats a single motif as a series, lined up in contiguous uniform rows.

Landscape

Landscape painting forms a particularly cherished part of the history of British art. The two major exponents of the landscape tradition in the nineteenth century, J.M.W. Turner and John Constable, are among England's most celebrated artists. Their impact was felt in later developments, most notably Impressionism, and their legacy extends to artists of the present day whose subject is landscape. The temptation to draw comparisons and search for models in the nineteenth century is great, and some contemporary painters freely acknowledge these sources of inspiration. Certainly, paintings of landscape in this exhibition are highly romantic in tone. And implicit in these romantic images are traces of the eighteenth- and nineteenth-century notion of the 'sublime' in nature, where a natural world is portrayed as picturesque and beautiful on the one hand, and terrifying and powerful, on the other. More striking than the shared thematic interest, however, are the similarities in material sensibilities between contemporary landscape painters and their precursors. Both Constable's emphasis on nature's abstract elements, and Turner's concern for the struggle between the elements which resulted in the dissolution of a material reality where the recognizable subject ultimately disappears, are evident, in varying degrees, in the work of Ian McKeever, Thérèse Oulton and Christopher Le Brun. The influence of yet another painter of landscape, Samuel Palmer, a follower of William Blake, is apparent in the obsessive, intimately scaled, pastoral studies of John Virtue.

Ian McKeever travels to remote, primeval locations in search of landscapes that inspire both wonder and terror. The Island of Staffa in the Inner Hebrides, unique for its majestic, volcanically formed caves, was the site for perilous expeditions in the nineteenth century by English painters and poets, such as Turner and Keats. Unlike Turner, who approached Fingal's Cave as a vista and 'blurred it into a broader landscape', McKeever transports us directly into the midst of the towering rock formations.[3] He achieves this effect both by scale, as he adjusts the space to the proportions of the human figure (his and the viewer's), and by technique, through which he conveys a sense of immediate physical activity and presence (Pls. 68, 69). McKeever's compositions begin with a collage of torn sections of black-and-white photographs, which are enlarged to show close-up details of the specific landscape. The painting-over process which follows is McKeever's attempt to 'relocate that image as painting'.[4] Thus, like Turner, he combines direct observation with memory. In his experimental handling of materials,

which signals a concern for achieving an authenticity of expression, the artist is closer to Constable, whose landscapes, McKeever claims, become 'abstract' more quickly.

In contrast to McKeever who seeks out exotic locations for his landscapes, John Virtue's sole subject is the tiny hamlet of Green Haworth in the Lancashire moorlands, where he has lived and worked for the past two decades. Virtue's interest is not in recording especially transient conditions of climate or other powerful natural phenomena. He is content, instead, to explore the multiple perspectives which offer infinite possibilities for experiencing an isolated bit of landscape. His individual, miniature variations on a single theme (a thicket, house or farm) are assembled in a grid-like serial fashion (Frontispiece & Pl. 41). They are meant to be read as a unified composite image, rather than as a sequential narrative. Although he uses traditional drawing media, Virtue considers his intricate, labour-intensive compositions as 'painterly'. This effect is generated by his dense web of cross-hatched lines through which he also achieves a Rembrandt-like chiaroscuro. Though Rembrandt's etchings are an inspiration to Virtue, another source for his imagery, closer to home, is Samuel Palmer. Palmer not only produced tiny, compact pastoral studies in etching; he also pursued an obsessive scrutiny of a particular place.

Thérèse Oulton's concern is with the 'properties of the natural world, but from within'.[5] Oulton turns the natural world inside out by unearthing its inner workings of subterranean dark and secret places. A tension between the physical and spiritual exists in her work which hovers on the boundary between figuration and abstraction. Oulton appears to be proceeding methodically toward the removal of recognizable imagery in her recent paintings, claiming that recognition inhibits the imagination. What appeals to Oulton in the landscapes of Turner and Constable is their abstractionist presentation and transformation of material processes. Oulton performs an alchemist's magic in transforming nature into art. Her gem-like, encrusted surfaces are achieved through an inventive combination of *alla prima* and glazing. In this way Oulton portrays nature, always mysterious, as both ephemeral and eternal (Pls. 70, 71).

The images that materialize in Christopher Le Brun's work are the result of an autogenetic process that takes place during the act of painting (Pls. 16, 17). For Le Brun, strokes of paint are both abstract and associative. A single mark might suggest the head of a horse, or branch of a tree. While these motifs have a significance that is not entirely formal, the artist, whose faith is in the innateness of his imagery to the picture, has stated: 'Painting is a kind of mask for my subjects which I will not discuss.'[6] Like others of his contemporaries who explore the subject of landscape, Le Brun vacillates between abstraction and figuration, though elements of both consistently recur in his work. The point of departure for his unpremeditated paintings is, however, his imagination. Le Brun describes himself as 'by temperament . . . a visionary painter after Turner and Blake'.[7] And, in the manner of these artists, he creates a tension between the actual and the visionary, from which his monumental paintings derive their power.

Personal Mythology

The paintings in this exhibition considered to be the elaboration of a personal mythology are not so much direct representations of an artist's own experience, as they are the artist's emotional and highly personal response to a situation. The figures in these revealing works are quite often both self-portrait and *alter ego*. Sometimes, the imagery recreates a state of mind, or describes a sentiment in the form of allegory. While the impetus for these paintings is always personal, they contain images which can be decoded universally. Amanda Faulkner and Gwen Hardie share a concern for recording the psychological and physical conditions of womanhood, while Eileen Cooper and Mary Mabbutt are inspired by scenes from their everyday lives. Stephen Conroy refers to the nineteenth-century academic tradition which informs his personal ideas about the nature of painting, while Stephen Barclay looks to contemporary German artists who similarly treat the subject of the aftermath of war. Andrzej Jackowski, Simon Edmondson and Adrian Wiszniewski depict interior visions which deal with memories of sensory

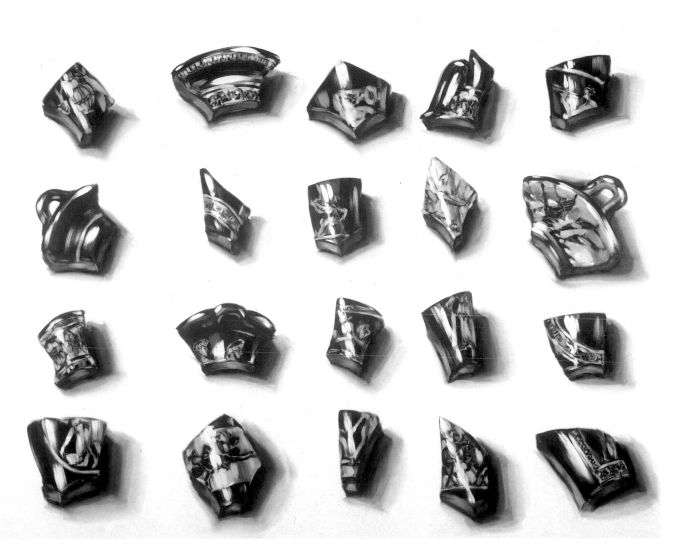

42 Lisa Milroy.
Fragments. 1987

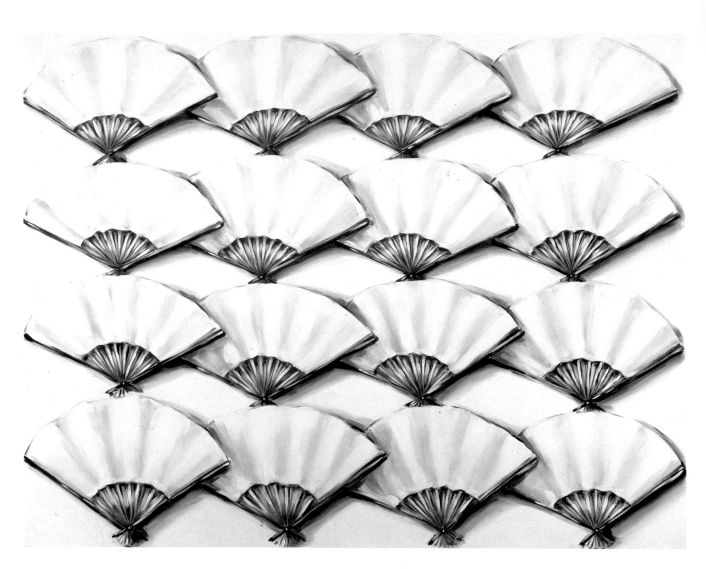

43 Lisa Milroy.
Fans. 1986

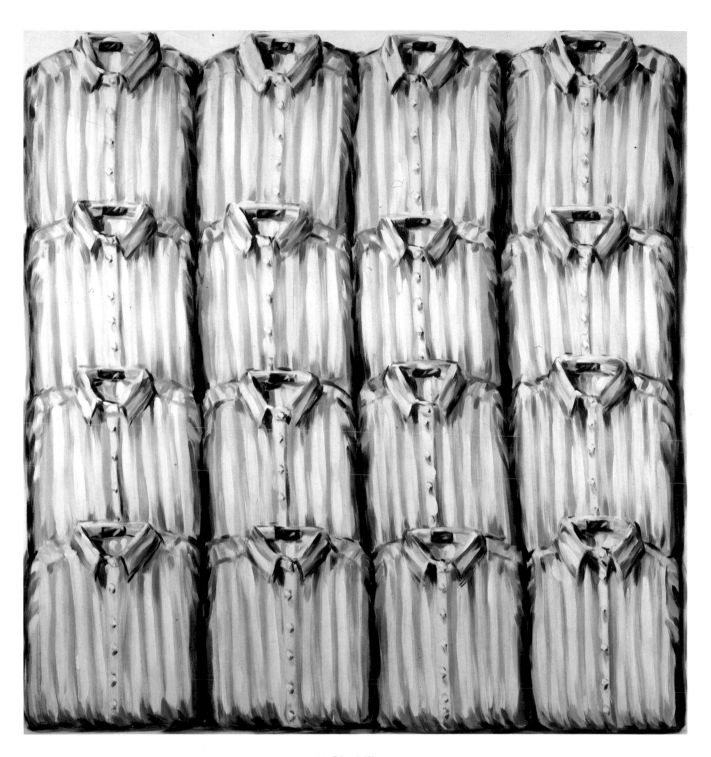

44 Lisa Milroy.
Shirts. 1986

45 Peter Howson.
A Wing and a
Prayer. 1987

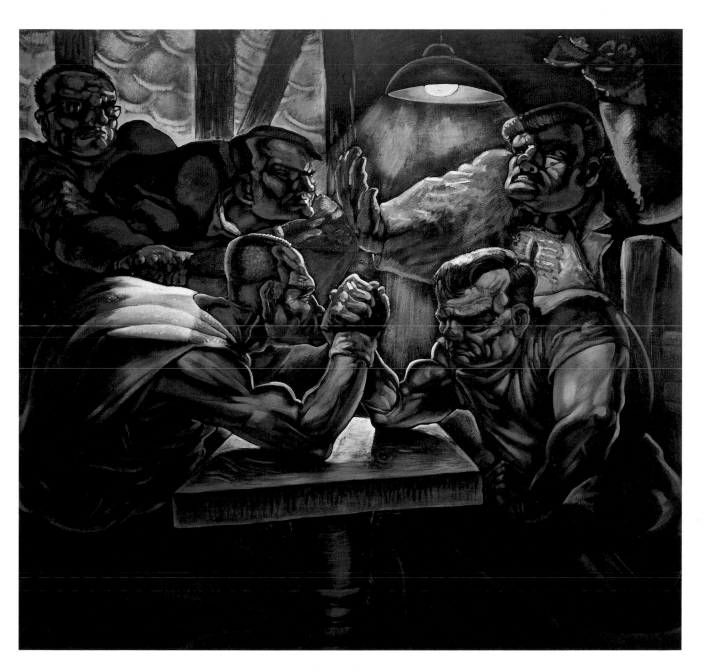

46 Peter Howson.
For Love nor Money.
1987

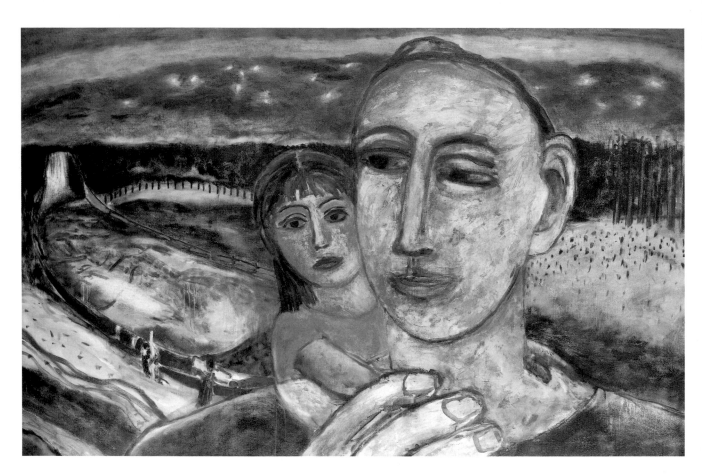

47 Andrzej Jackowski.
Earth-Stalker. 1987

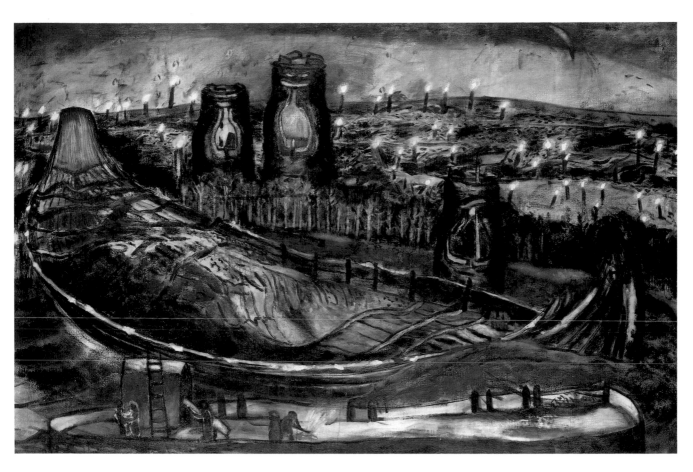

48 Andrzej Jackowski.
Settlement—with
Three Towers. 1986

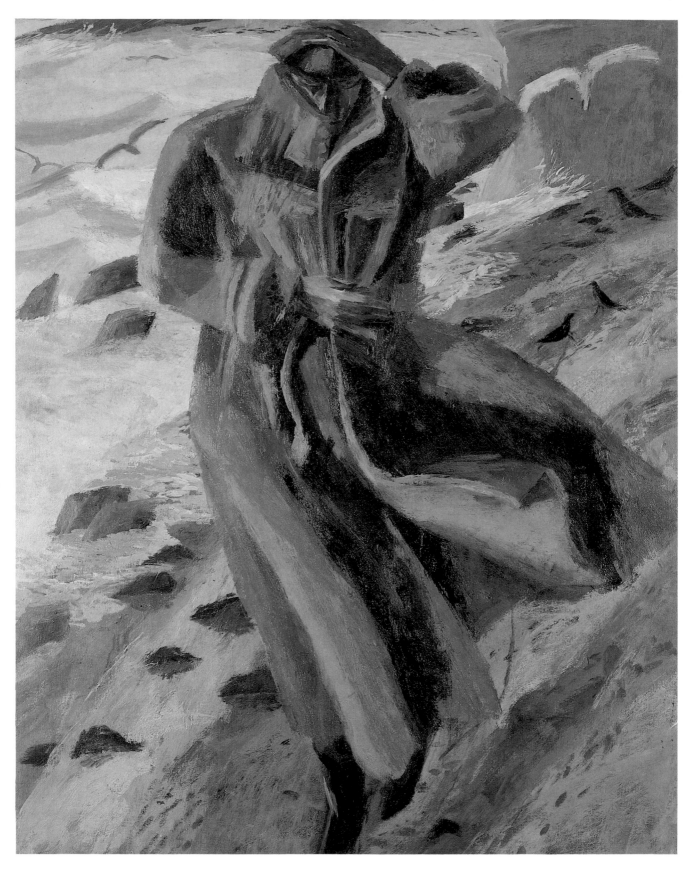

49 Mary Mabbutt.
Walking on the
Beach. 1985

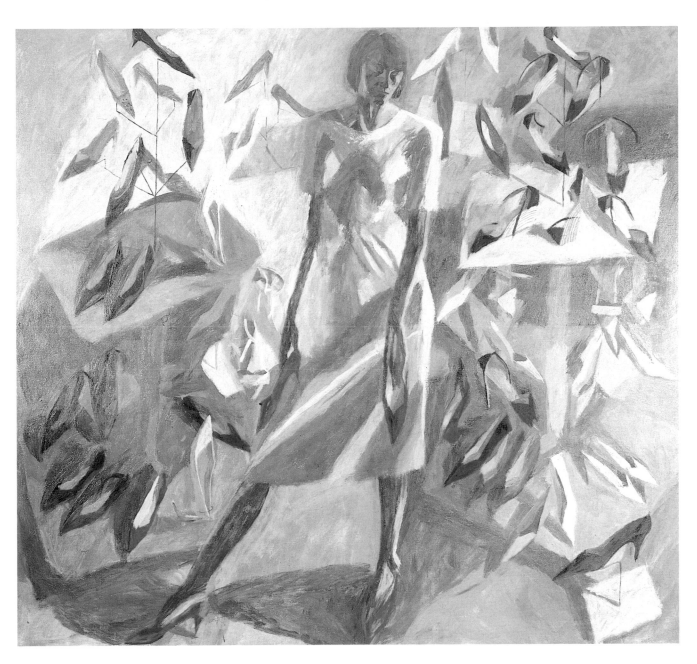

50 Mary Mabbutt.
New Shoes. 1983

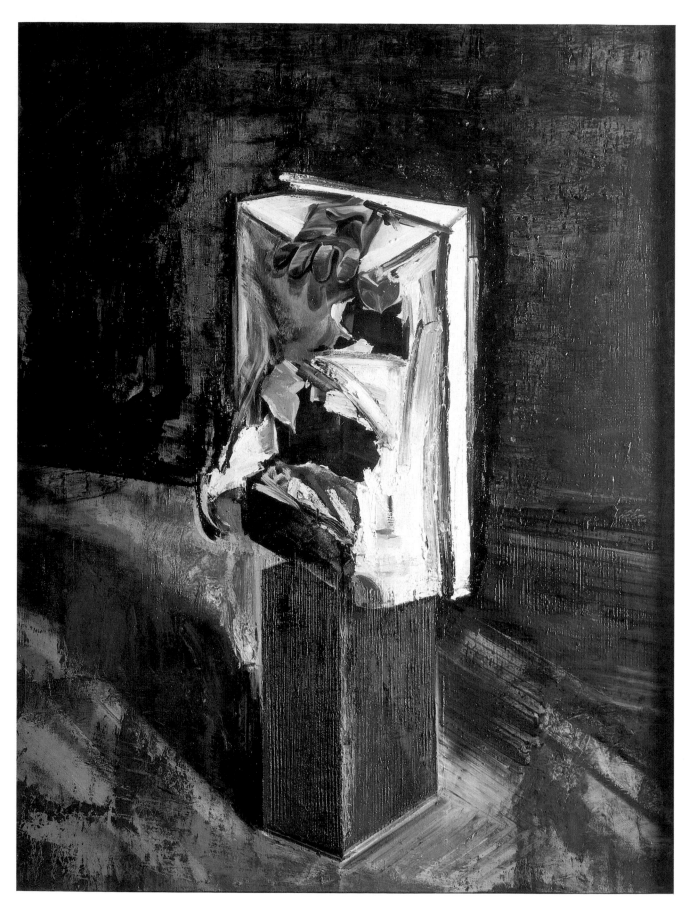

51 John Monks.
Suitcase with Gloves.
1985

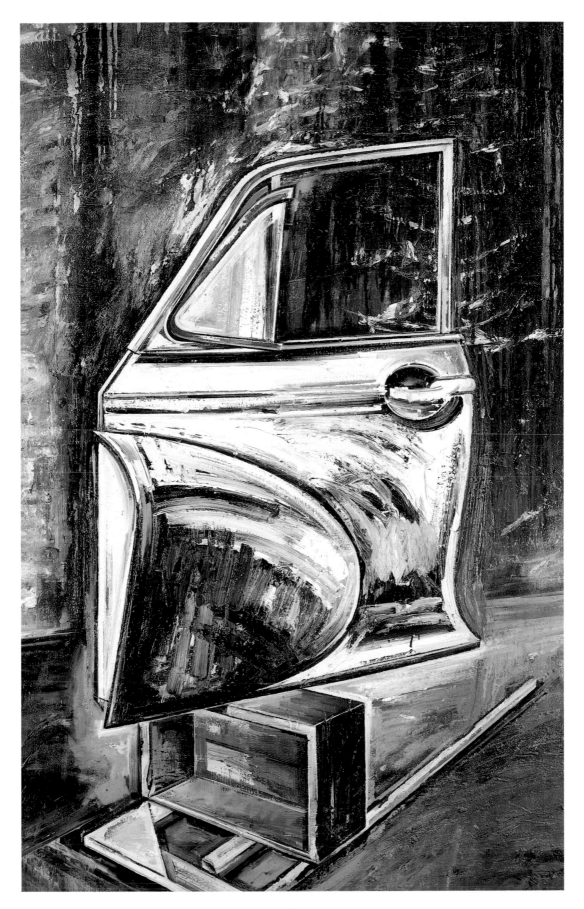

52 John Monks.
Car Door. 1986

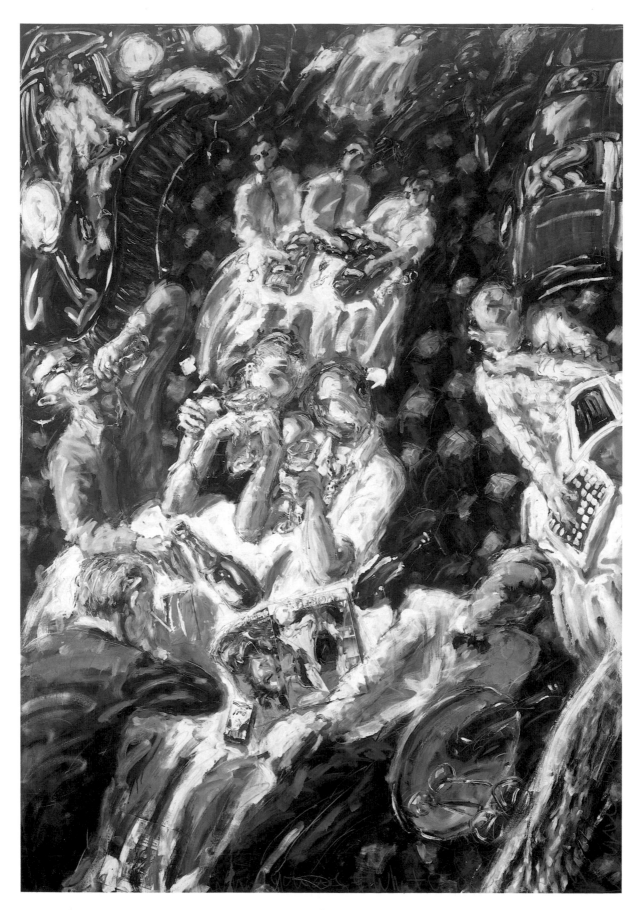

53 John Keane.
Who You Are and
What You Do.
1986–7

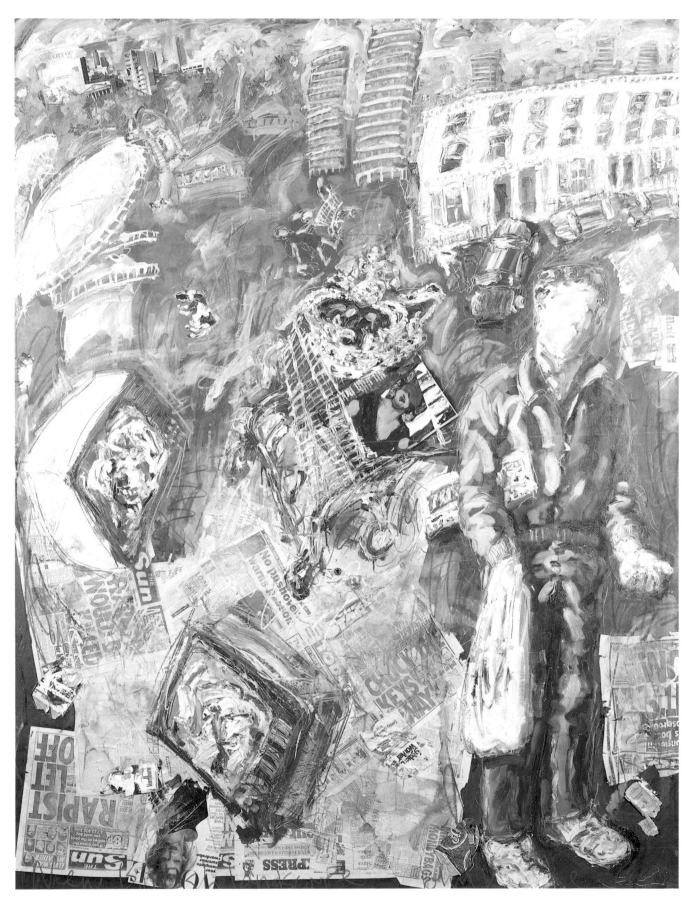

54 John Keane.
*New British
Landscape*. 1987

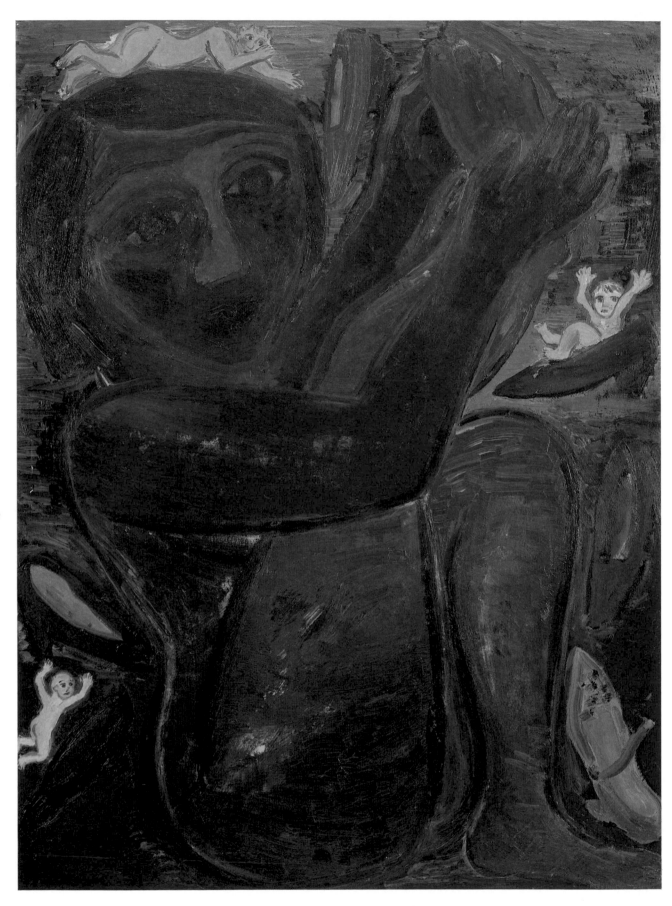

55 Eileen Cooper.
If the Shoe Fits. 1987

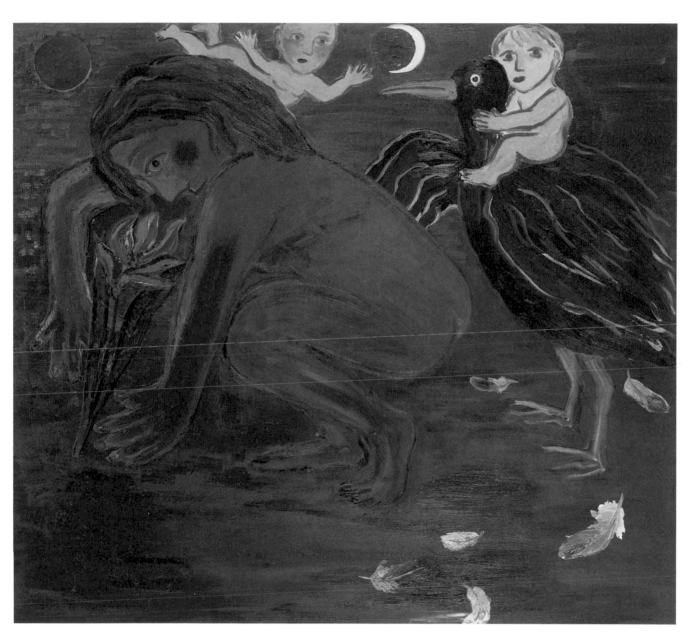

56 Eileen Cooper.
Babies. 1987

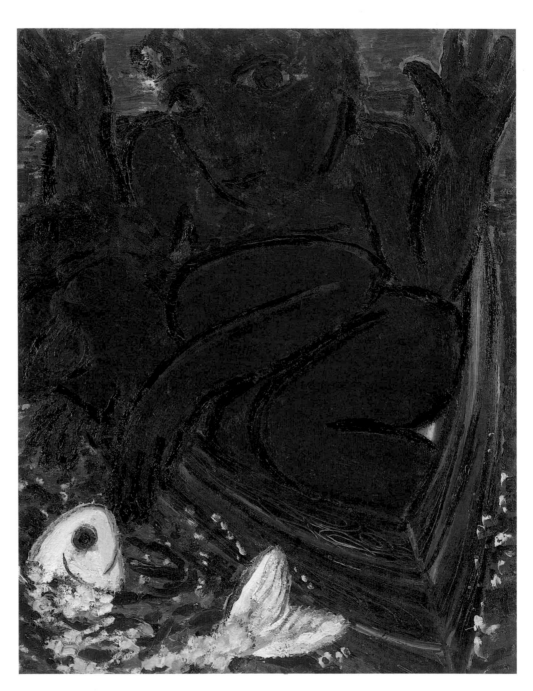

57 Eileen Cooper.
Over the Side. 1987

experience, rather than individual incidents from their pasts, in paintings intended both to capture and evoke a mood of reverie.

Amanda Faulkner explores the multifaceted female personality by representing women in a panoply of traditionally ascribed roles. Her characters are often versions of the same woman, as in *Inside Out* (Pl. 24). The primitive icon, 'feminized' by a ridiculous hair ribbon, edges into the foreground, where a comatose woman appears as little more than a stylish-looking automaton. Surrounded by those with whom she is interdependent, and consequently, about whom she is ambivalent, Faulkner's woman is both consumed and defined by her relationships with others. Male demons masquerading as babies express the artist's abnegation of the mythic role of woman as benevolent nurturer. Faulkner is clearly out to subvert the traditional Madonna and Child fantasy of the male artist. The detached organs that float absurdly in space remind us that women are tyrannized by their own bodies.

Like Faulkner, Gwen Hardie has in mind the formulation of a depictive language that offers an alternative to the female prototypes developed by male artists. Her monumental, blown-up anatomical details communicate her ambition to re-invent the female body, inch by inch, from the woman's point of view. In her painting, *The Brave One* (Pl. 25), Hardie concentrates on the external aspects of her body, re-creating the skin's surface as pigment. The artist forges a tactile, immediate relationship with her images by using the body's own tools—her fingers—to apply and mould the paint directly onto the canvas. Although she uses her own body as a reference point, Hardie's 'self-identifications' are not in the least narcissistic. Rather, they are resolute statements of female authority, underscored by her active presence as both subject and artist.

The rationale for Eileen Cooper's paintings, which revolve around women as central figures, is 'to make sense of my life, to celebrate it'.[8] Cooper's work maintains a strong sense of narrative when read as a succession of images acting as entries in a visual diary. The artist combines mask-like faces reminiscent of Picasso with a vivid Fauvist palette to reproduce a primitive state of the imagination that is not, she states,

'restricted to a logical description of the world'.[9] While autobiographical in inspiration, Cooper's stories are meant to be more universal in implication. Closely paralleling events in her own life, Cooper's imagery has evolved from monumental, generic mother-and-child paintings to intimately scaled, direct depictions of a single female figure. Often, as in *If the Shoe Fits* (Pl. 55), the figure is engaged in some mundane female ritual. As a concept both new and unknown to the artist, motherhood assumed mythic proportions; as an activity, it became increasingly demystified. In *Babies* (Pl. 56), the infants who occupy a space in the background of the painting, are now viewed as just one part of a woman's life, rather than as the phenomena which traditionally bind women to a limited cultural definition.

Mary Mabbutt's paintings are also re-creations of moments from her own experience. Unlike Cooper's images, however, Mabbutt's transcriptions of events are more literal than allegorical. While memorable to the artist, these events are often quite ordinary and the impulse to paint them arises spontaneously. Mabbutt exploits the manner in which clothing can convey a mood or sensation. In *Walking on the Beach* (Pl. 49), her bulky overcoat conjures up the cold, harsh climate of Falmouth, the artist's home in south-west England. Mabbutt also employs clothing as a pictorial device, and reduces familiar items of apparel, such as shoes, to arrangements of planar, fragmented forms. This concern for geometry aligns her with certain English artists of the early part of this century, such as Wyndham Lewis and Christopher Nevinson. The significance which she attaches to subject-matter, however, prevents her from moving further toward abstraction.

Stephen Conroy's paintings seem, at first glance, like anachronisms. The sombre, brooding atmosphere of his oppressive, stuffy interior scenes would place them more comfortably into a late-Victorian or early-Edwardian setting. They are uncompromisingly formal, down to the last detail of their ponderous 'period' frames. Furthermore, Conroy keeps them behind glass to deliberately 'cut them off' from the viewer.[10] What makes this prodigious artist (at twenty-four, the youngest in the exhibition) at once

curious and remarkable is his acute sense of composition, both rigidly ordered and restrained. In *167 Renfrew Street* (Pl. 14), Conroy lets us into his private vision of a drawing class at the Glasgow School of Art, where young men are stiffly dressed in proper attire to denote the solemnity of the occasion. Firmly committed to the classical tradition, and heir to the legacy of fine draughtsmanship associated with Scottish painting, Conroy uses this context to make a potent statement about academicism (Pl. 15). Conroy admires Degas and Sickert for their 'sense of dissonance', or the way in which they could distill a mood of deep unrest out of their depictions of scenes from everyday life.[11]

Stephen Barclay has converted the legacy of war and its aftermath into a personal mythology. The experience of World War II is inextricably woven into Barclay's family history, and his imagery is inspired by the indelible memories passed down by his parents, both of whom served in the Armed Forces. In *The Parachutist* (Pl. 13) and *Night Tower* (Pl. 12), the artist isolates the solitary figure or architectural remnant in abandoned military sites, which cast what he calls 'war's permanent shadow' over the Scottish countryside.[12] Barclay integrates his preoccupation with war with his primary impulse as a painter of desolate, melancholy landscapes. In this way, he reveals his affinity with the modern generation of war-obsessed German artists, particularly Anselm Kiefer, whose influence Barclay acknowledges.

The paintings of Andrzej Jackowski elicit a mood of reverie that matches his interior visions of the ambiguous state between imagination and reality. For Jackowski, the facture of the painting is as provocative as the image portrayed. The artist brushes in suggestions of images with sepia, and gradually builds up the surfaces of his paintings with glazes through which he achieves the dreamlike effect of an ethereal luminosity. Many of the motifs found in Jackowski's imagery are intended as metaphors for the retrieval of one's past. The large head in *Earth-Stalker* (Pl. 47) functions as a composite self-portrait. Part observer and part mnemonic muse, the head both bears witness to the artist's past and inspires him to create images unique to his own experience. In *Settlement—with Three Towers* (Pl. 48), he reconstructs childhood memories of confinement in a refugee camp in the north of England. The boat and towers, which recall his impressions of wooden barracks, serve as autobiographical enclosures not unlike the dream state into which a displaced person retreats.

Simon Edmondson's sumptuous, romantic paintings share with Jackowski's the ability to transport the viewer into another realm (Pl. 22). The setting for Edmondson's images is the mental landscape in which the spiritual and the physical co-exist. The artist often uses colour (or the absence of it) and line not so much to distinguish one world from another, but rather to convey different shades and intensities of emotion. In *A Hundred Ardent Lovers Fell into Eternal Sleep* (Pl. 21), these distinctions become nebulous. Aroused by the act of love, the apparitions that crowd the earthbound lovers belong to a collective subconscious in which past and present lives are united.

Adrian Wiszniewski's paintings, like those of Jackowski and Edmondson, are best understood as depictions of dreamscapes, fraught with symbols that relate to a personal iconography. The subject of Wiszniewski's sensual and allegorical narratives is the restless state of adolescence. And the languorous youths who appear in his enigmatic scenes are the artist's *alter ego*. In a manner more graphic than painterly, Wiszniewski uses swirling ribbons of bright pigment to construct elaborate mazes that communicate the attendant confusions and ambivalent desires of pubescence (Pl. 79). Filled with blossoming flowers and phallic imagery, the eroticized landscapes that surround Wiszniewski's figures are metaphors for diffused sexual passions. But his dizzying labyrinths are really intended to caution us that Wiszniewski's narratives, like irrational dreams, are not meant to be read logically. Even his titles are puzzles. *Nuclear Fission* (Pl. 78) might refer to the process of reproduction that occurs when atoms are split. It is, however, more likely about 'fishin'' and how a youthful mind transposes preposterous-sounding, meaningless concepts into an empirical framework.

Social Concerns

Contemporary painting based on social concerns runs the gamut from gentle satire to

Opposite:
Detail of Plate 19
(Ken Currie: *In the City Bar*)

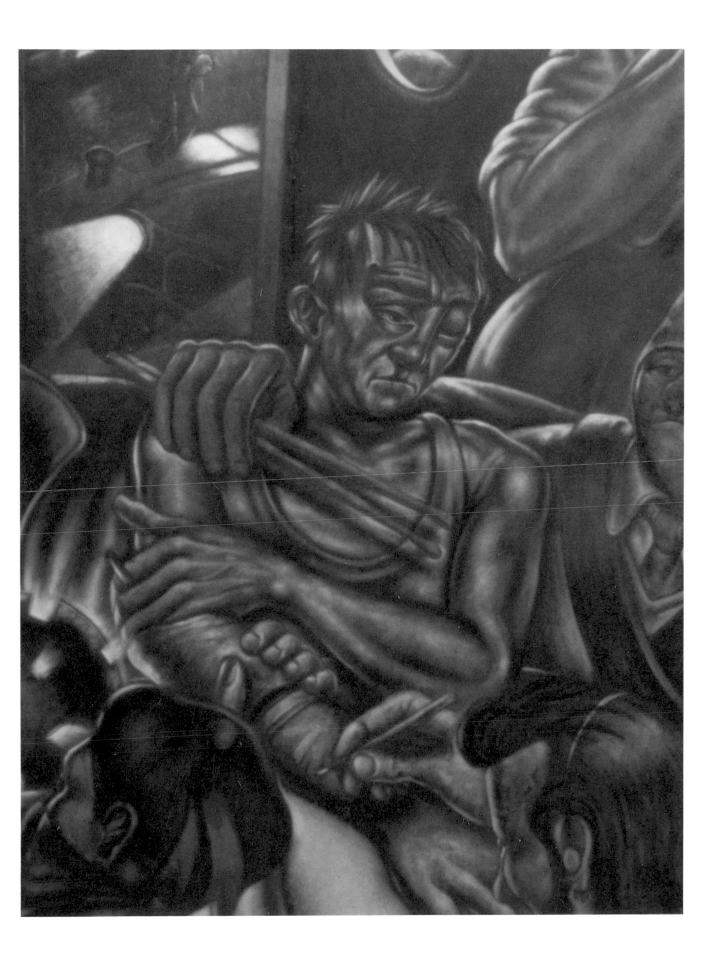

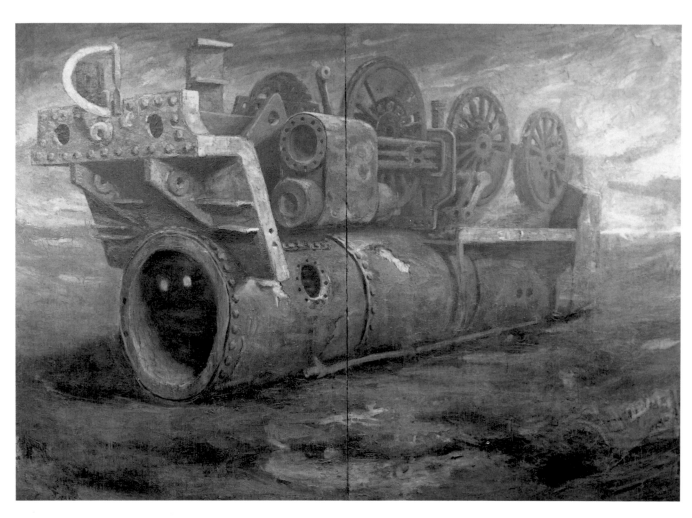

58 Jonathan Waller.
Sequel. 1987

political propaganda. Both society and culture are the targets of this group of painters. Certain artists focus on a particular social class: John Keane, on the idiosyncracies of London's new middle class; Jock McFadyen on its lower classes; Ken Currie and Peter Howson on realistic portrayals of Glasgow's impoverished working class. Kevin Sinnott explores social problems endemic to human nature, while Suzanne Treister, Tim Head and Graham Crowley use elaborate symbols to portray the grim, destructive elements that threaten contemporary society. The Post-Industrial age and its effects on the British value system are important to Steven Campbell and Jonathan Waller, while Mark Wallinger confronts the English national past head on.

John Keane's brand of social satire addresses 'the quirks and ironies of living in the twentieth century'.[13] The target of his often humorous, sometimes caustic exposés is the modern breed of white-collar, socially mobile, salaried professional—the 'yuppie'. This prosperous new middle class rarely appears as a subject in British painting. And it is an irony (which even the artist acknowledges) that Keane mocks the very segment of society that buys his work. In *Who You Are and What You Do* (Pl. 53), he depicts a crush of well-appointed, faceless individuals in a chic London cocktail bar, as a modern parable of sex, drugs and money. Keane softens his diatribe and livens up his compositions with touches of wit and humour, achieved through technical devices such as energetic brushstrokes, oblique perspectives and collages of real objects applied onto the canvas.

A fifty-pence ride on the London Underground is not all that separates Keane's smart West Enders from Jock McFadyen's gritty East Enders. Nowhere is this distance more acutely described than in McFadyen's images of working-class street life. His repertoire ranges from prostitutes, as in *Rainy Day Women, L8* (Pl. 82), to hucksters, skinheads and mothers pushing prams. The common denominator is poverty. The artist attempts to simulate the objectivity of photography, from which he derives certain visual techniques, notably in the angles and spatial organizations of his compositions. The caricature and grotesquerie of his figures, as well as the brightness of his palette, provide moments of comic relief in otherwise grim

portraits of spiritual neglect. McFadyen's dockside genre subjects are, for the most part, neither judgemental nor critical in tone. He assumes quite a different posture, however, in paintings drawn from his experience in Northern Ireland, which are unequivocally condemning of religious intolerance. In *Parade* (Pl. 18), McFadyen uses caricature to mock the Orangemen (members of the Protestant sect) as they march through Belfast, portraying their leader as a pompous circus dog, decked out in Lodgeman's finery.

Ken Currie and Peter Howson focus on the problems of modern Glasgow as a microcosm of the human condition. Theirs is a city laden with the most extreme examples of the misery wrought by harsh working conditions, poor housing and widespread poverty. Unlike the noted Glasgow School of painters of the turn of the century, such as James Guthrie, Robert McGregor or E.A. Walton, in whose attempts at realism, portrayals of the poor tended to be picturesque and sentimental, Currie and Howson employ instead the mode of representation of the German painters of the *Neue Sachlichkeit*. These young Scottish artists aim for an uncompromising realism, in which situations are presented with detailed and exaggerated forthrightness.

For Currie, a politically committed artist who comes close to the Mexican muralist Diego Rivera in articulating socialist ideology on a grand scale, the 'struggle' is paramount. Currie's agenda is clear; he makes art 'about working people, for working people . . .'[14], and he subscribes to the power of art to motivate people to improve their lot. Citing ignorance as a great impediment to progress, his engrossing, complex scenes portray members of the working classes involved in self-educational pursuits (Pl. 20). A more despondent Currie appears as the worker/artist, tearing up his grand design for a better world, in a sequence from his *In the City Bar* (Pl. 19).

Like Currie's paintings, Howson's hard-hitting unsentimental images are filled with the wretchedness and despair of Glasgow's poor. His subjects are young, musclebound toughs, engaged in 'masculine' activities—streetfighting, wrestling or football. Yet, even though he abhors violence, Howson understands its origins. Glasgow's dossers—derelicts forced to sleep in cheap lodging houses—are the real heroes of Howson's low-

life tragedies. Like the figure in *A Wing and a Prayer* (Pl. 45), they assume heroic proportions and, though weighed down by the burden of constant hardships, they remain proud and defiant.

For Kevin Sinnott, tension is the common denominator of human relationships. Much of the uneasiness that pervades his imagery is derived from the situation itself, as he often portrays characters who are poised on the brink of some imminent confrontation. Sinnott depends upon stark lighting, stagy spatial rendering and exaggerated gesture to complement the drama contained within his paintings. Classical mythology is a particularly rich source for his thematic concerns and Baroque sensibility as in *Mother and Child* (Pl. 72), based on the legend of the Sabine women. Sinnott's image is a vivid adaptation of Plutarch's account of the terror-stricken victims of the surprise attack by Roman soldiers. In *Thin Ice* (Pl. 73), two figures are frozen in the awkward moment that precedes a forced intimacy. The colossal Prometheus, straining to free himself, presides over the ceremonies at the Rockefeller Center ice-rink and offers a striking counterpoint to Sinnott's pair.

Suzanne Treister's rich, seductive paintings are made up of improbable juxtapositions that can be both humorous and menacing. Treister uses the human heart as a surrogate for the actual figure because it is, to her, 'the centre, both physical and emotional' of life.[15] In *Electric Chairs* (Pl. 74), the arteries that emanate from the heart connect the human presence with the inanimate objects, the chairs, in the composition. But while these arteries function as conduits for the life force, they also contain an active electrical current. Thus, the artist is proposing an allegory for our potential for self-destruction. She carries this notion further in *Detail of God's Underwear* (Pl. 75). The electric drills which draw their source of power from the heart are overtly phallic symbols which Treister describes as 'instruments of potential violence; you don't really know what they are drilling into.'[16]

The point of Tim Head's image mutations is to reveal 'an artificial terrain of simulated textures and shapes in which, silently, anything can be changed into anything else.'[17] Thus, he seduces the viewer with tastefully designed patterns which, on closer inspec-

tion, turn out to be as banal as lamb chops, or as revolting as entrails (Pls. 80, 81). By reminding us that things are not always what they appear to be, however, Head intends not merely to raise questions about the fallibility of our perceptions. Rather, he addresses a larger concern for the way in which society has become the victim of the consumer culture it created. Not only are we reduced to products; we are, literally, what we eat. Environmental poisons, which threaten our interior mental and physical spaces, are most insidious when they come in pretty packages.

Graham Crowley addresses a multitude of contemporary social issues in paintings of domestic life. While his interior scenes contain 'homey' conventions, such as brightly lit table lamps, Crowley's urban psychodramas are anything but comforting. The chaotic and squalid claustrophobia endured by city dwellers recalls the documentary and moralist tone of Charles Dickens, and the chilling prescience of George Orwell. Crowley unmasks obsessively pretentious notions of manners and decorum as hopelessly anachronistic in a modern setting. The house in *Peripheral Vision* (Pl. 67) is no longer a safe haven; its walls and doors, formerly barriers to evils that threaten its boundaries, are now reduced to rubble. The compressed, distorted spaces, and lurid effects of lighting are the visual equivalents of a nightmarish state of anxiety and despair.

The monumental, narrative paintings of Steven Campbell are complex in arcane detail, and rich in formal invention. Campbell draws upon a vast reserve of literary and illustrative sources, which intermingle with his imagination in fantastic scenarios ('I paint like someone who is trying to put as much as possible in.'[18]). Much of his imagery comes from his dual fascination with powerful myths and scientific or pseudo-scientific experiments. One popular myth which he persistently debunks in his paintings is that of a pastoral, rural England which ceased to exist long ago. Campbell shares this view of an Arcadian fiction and penchant for absurd happenings with P.G. Wodehouse, whose novels inspired the artist's paintings of Wee Nook (Pl. 10). But Campbell's imagery conveys a mixture of humour and horror which Wodehouse never attempted. Campbell's world is one of terrifying situations and threatening environments which

Opposite:
Detail of Plate 10
(Steven Campbell:
'Twas once an Architect's Office in Wee Nook)

seem to come together on some surreal stage. He exploits theatrical devices—dramatic poses and gestures, and landscapes serving as backdrops—retained from his days as a performance artist. As in *The Man who Gave his Legs to God and God Did not Want them* (Pl. 11), his lunging characters seem to defy gravity as much as their predicaments defy logic.

Jonathan Waller's haunting *Sequel* (Pl. 58) proposes an epilogue to the ascendancy of the Industrial Age, heralded in Turner's 1844 masterpiece *Rain, Steam and Speed* (see Pl. 3). The abandoned, decaying locomotive, once the symbol of progress, is now reduced to a metaphor for a failed dream. Belly-up, it appears frozen in time like a petrified work horse. Waller's paintings of industrial archaeology owe a debt to nineteenth-century Romanticism both in the facture and approach to subject-matter. The material property of the paint is transformed into rust, while the warm ochre tonality evokes a mood that is more elegiac and wistful than disturbing.

If Sir Joshua Reynolds instructed the eighteenth-century Royal Academy's practitioners of the 'Grand Manner' of painting to restrict their subject-matter to references to poetry or the past, he would recognize his progeny *in extremis* as the contemporary history painter, Mark Wallinger. Wallinger lampoons the English national past by acknowledging the 'non-conformists' of the eighteenth and nineteenth centuries. In *Satire Sat Here* (Pl. 77) William Hogarth's image of the *Comic Muse* (a self-portrait in the act of painting) is relocated into opposing toilet bowls, which form both a visual palindrome and a mask. The reference to where 'Satire' sat places Hogarth in a context in which his socially critical art, as viewed by his contemporaries, would have been considered in very bad taste. Wallinger's *In the Hands of the Dilettanti* (Pl. 76) is borrowed from Sir Joshua's group portrait of the Society of the Dilettanti (whom William Blake called 'Sir Sloshua and his gang of hired knaves'). Perched in the foreground is a toby-jug in the form of Blake's death mask. Blake takes on the role of both martyr and prophet in Wallinger's sad homage. Whether quoted in ironic, critical or subversive terms, Wallinger uses the past to comment on the present. The issue he addresses is, after all, the survival of British Painting.

Opposite:
Detail of Plate 67
(Graham Crowley:
Peripheral Vision)

1 The 'School of London' is the name given to this group of artists by the American-born R.B. Kitaj.

2 Quoted in Monica Bohm-Duchen, 'John Monks', *Flash Art*, January/March 1986

3 Ian McKeever and Thomas Joshua Cooper, *The Staffa Project: A Collaboration*, Harris Museum and Art Gallery, Preston, 1987, p. 44

4 Interview by Matthew Collings, *Artscribe* 46, May/July, 1984, p. 20

5 Quoted in Patrick Kinmonth, 'Thérèse Oulton Painting', *British Vogue*, July 1984

6 Quoted in Caroline Collier, 'White Horses . . .Christopher Le Brun', *Studio International*, vol. 192, no. 1010, 1985, p. 15

7 Ibid., p. 15

8 Quoted in interview with Philip Vonn, 'Eileen Cooper: Painting from a Life', *Artist's and Illustrator's Magazine*, September 1987, p. 11

9 Ibid., p. 11

10 Quoted by Andrew Graham-Dixon, 'Unquiet Mood', *British Vogue*, February 1988, p. 218

11 Ibid., p. 210

12 Quoted in Alexander Moffat, *New Image Glasgow*, Third Eye Centre, Glasgow, 1985, p. 9

13 Quoted in Robert Heller, *16 Artists' Process and Product*, Angela Flowers Gallery, London, 1987

14 Quoted in interview from information pack, 'In Touch with New Scottish Art', published in conjunction with *The Vigorous Imagination: New Scottish Art*, Scottish National Gallery of Modern Art, Edinburgh, 1987

15 Interview with the artist, February 1988

16 Interview with the artist, February 1988

17 Quoted in Marina Vaizey, 'British Art Makes a Name for Itself', *The Sunday Times*, 25 January 1987

18 Quoted in interview from information pack, 'In Touch with New Scottish Art' (see note 14)

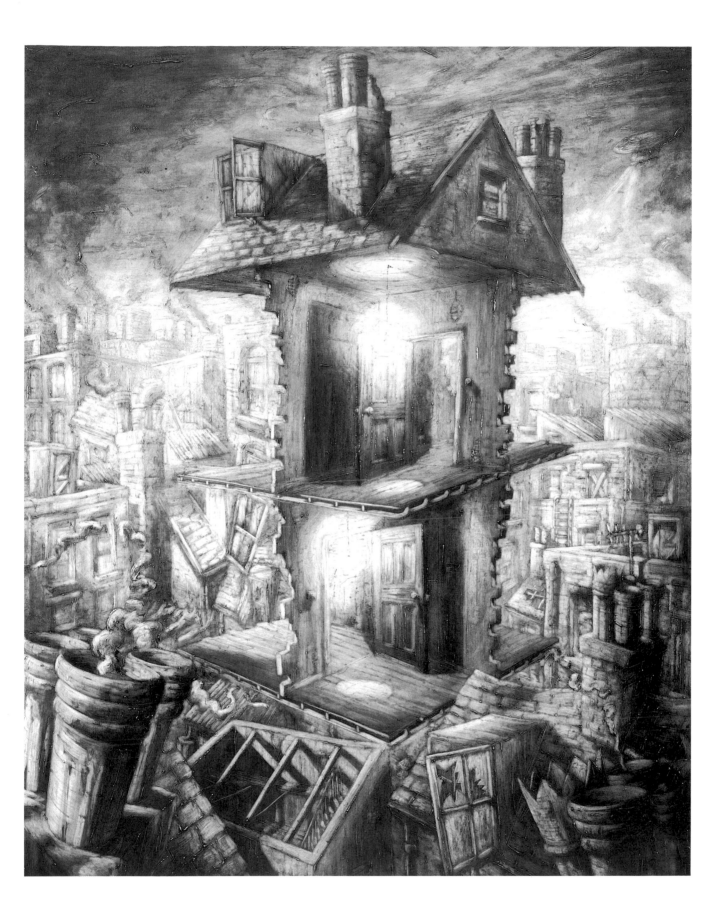

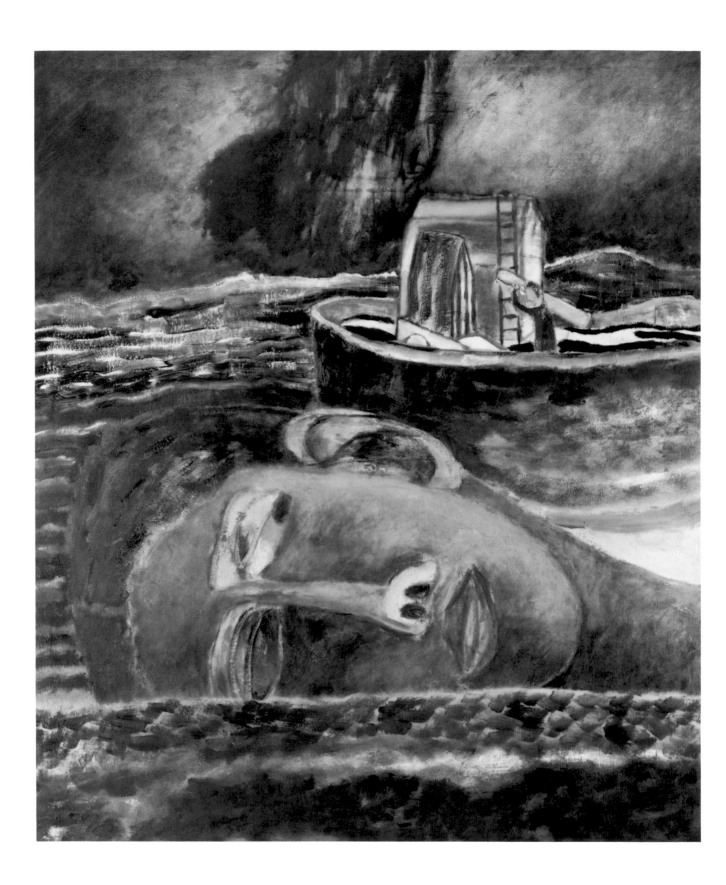

AN AMERICAN VIEW
Judith Higgins

British painting is today experiencing a glorious resurgence. In the catalogue essay for the 1976 figurative exhibition *The Human Clay*, which R.B. Kitaj organized to refute the idea that painting, and in particular the human figure, were 'finished', he expressed the hope that the human image would 'survive [the 1970s] in new form and shape'. British painting in the 1980s is unequivocally fulfilling that hope. Indeed there are so many good painters at work in Britain that this exhibition does not have room to include them all. However, in this essay it is possible to mention a few more artists who have already been acclaimed in London and who are beginning to receive recognition in the United States.

Contemporary British painting has not achieved its current high status suddenly. The origins of the image-laden, passionate, individualistic, well-executed painting that British artists exhibited in *A New Spirit in Painting* (London 1981), the Berlin *Zeitgeist* (1982), *The Vigorous Imagination: New Scottish Art* (Scottish National Gallery of Modern Art, Edinburgh, 1987), and in the Venice Biennials of Howard Hodgkin and Frank Auerbach go back to the beginning of the century—to strong British traditions of figuration, landscape, narrative, romanticism, surrealism, and to sculpture; to thorough academic training, particularly in drawing; to transformations that British painting has worked upon European Modernism and

Opposite:
59 Andrzej
Jackowski. *The Vigilant One*. 1984.
Oil on canvas,
71⅞ × 60 in
(182.5 × 152.5 cm).
Courtesy
Marlborough Fine
Art, London

American Abstract Expressionism in, for example, Vorticism and St Ives abstraction; and to individual painters: Constable and Turner; Nicholson, Nash, and Sutherland; Sickert, Spencer and Bomberg. Their names were invoked frequently by the painters who were interviewed for this essay, indicating that the work of these 'father figures' informs current painting, just as do the painters' lives and physical and social environments.

Both the recent and distant past has contributed greatly to the painting of the 1980s. First, although assailed by alternatives (Minimalism, Conceptualism, photography, performance, Art and Language), figurative painting remained important during the 1970s. Among those persisting with figuration were both the School of London painters and the narrative painters: Victor Willing (Pl. 60), Craigie Aitchison, Ken Kiff, Paula Rego (Pl. 62), John Bellany, and Andrzej Jackowski. The years of critical neglect gave artists the time to follow out their own visions, without any accompanying publicity or the pressure to exhibit. Thus, Neo-Expressionism, when it fanned out from Italy and Germany at the beginning of the 1980s, created the climate in which such figurative painting, which had been awaiting discovery, could be shown.

Furthermore, and to its great advantage, the painting of the 1980s has retained aspects of the art forms of the 1970s: namely, sculpturality, but now in the paint; the incorporation of photographs into the paintings; the

75

theatricality of performance art, in the self-as-hero paintings of Kiff, Rego, Jackowski, and Campbell; an awareness of social context, even in paintings that in a previous era might have been totally subjective, such as those by Graham Crowley; and finally, the revitalization of landscape and still-life traditions through Conceptualism and consciousness of process. For example, landscape painter Ian McKeever's most recent paintings have involved an elaborate process of burning photographic film and staining the canvas with tea as he experimented with bringing images of the austere Scottish island of Staffa in and out of recognizability. 'Conceptualism still informs what I do', he commented.

Whether transformed by the passage through Abstraction and Conceptualism, or left unscathed, all modes of British painting entered the 1980s thriving; clearly, what to do after Modernism was not going to be a dilemma. The 1978 show of Neo-Classical painter Stephen McKenna can be considered a harbinger of the return to picture-making (Pl. 63). Alienated by the Abstract Expressionism taught to him at the Slade, his work called ridiculous by his friends, McKenna had left Britain for Germany seven years earlier. He returned to exhibit portraits, landscapes, still lifes, and 'mythology pictures' in styles ranging from that of Claude, Poussin and Chardin, to Constable and de Chirico.

Meanwhile the older generation of

60 Victor Willing.
Untitled. 1981.
Pastel, 17 × 22 in
(43.2 × 55.9 cm).
Courtesy Bernard
Jacobson Gallery,
London

61 Bruce McLean.
Untitled. 1986.
Acrylic, enamel
and collage on
canvas, 111 × 79 in
(281.5 × 200.5 cm).
Courtesy Anthony
d'Offay Gallery,
London

English Geometric Abstractionists have proved as stubborn in their ways as the School of London painters. Peter Joseph has continued to set shimmering 'windows' of light paint within slender dark frames; Bridget Riley to manipulate her dazzling stripes; and Alan Charlton to work subtle variations on sets of grey Minimalist canvases. And alongside the School of London and narrative painters are a number of young Scottish painters, whose widely varied but consistently strong figurative work was launched at the 1982 Edinburgh Festival and at Third Eye Centre's *New Image Glasgow* exhibition in 1985.

A number of artists who had vigorously expressed aesthetic, political, and social concerns in other media in the 1970s, turned to painting in the 1980s. Deriving from his scores for performances, Bruce McLean's swift, linear figures, on canvases saturated by bucketsful of paint (Pl. 61), continue to satirize social mores, poses, and props (the ever-present stepladder for social climbing, for example). Gilbert and George, who used to be 'living sculptures', now make multi-panel photopieces of collaged, brightly hand-dyed images—blasphemous church-windows—in which the pair relegate themselves to the role of spectators and feature a line-up of idealized young East End males, while attacking the physical and social background of urban squalor.

With the revival of painting and content, the image again prevails. The artists' neigh-

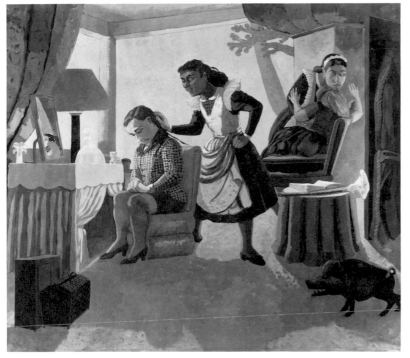

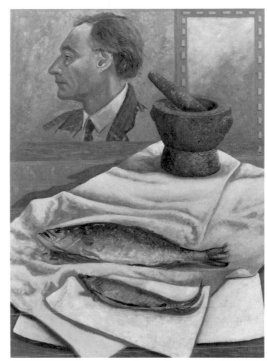

62 Paula Rego.
The Maids. 1987.
Acrylic on paper
mounted on
canvas, 84 × 96 in
(213.3 × 243.8 cm).
Courtesy
Marlborough Fine
Art, London

63 Stephen McKenna.
Self-Portrait. 1987.
Oil on canvas,
32 × 24 in
(81.2 × 61 cm).
Courtesy Edward
Totah Gallery,
London

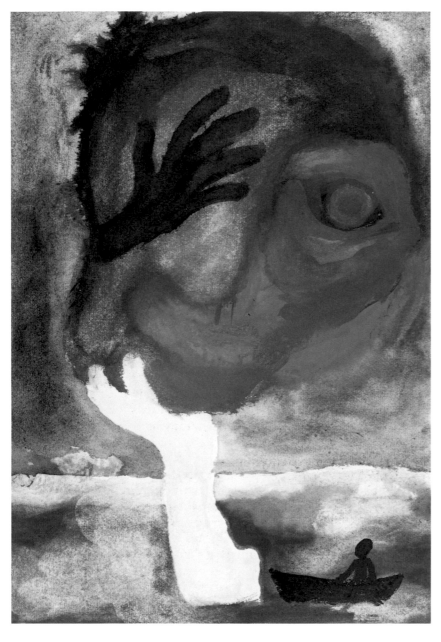

artists who paint the naked inner man on his journey through life. For example, Ken Kiff's unfolding psychological auto-biography, 'A Sequence', begun in March 1971, has inspired over 200 paintings so far (Pl. 64).

Other British painters have looked beyond the self and their close personal circle for their imagery without, however, losing any of the initial emotional impulse. Kitaj is the Old-Master borrower; while autobiographical, his work has always been peopled with *personae* from politics, poetry, the theatre and, increasingly, from the tragic history and present perils of the Jewish people. Regarding the current eclecticism of the younger painters, gallery owner Anthony Reynolds comments, 'The great thing in the last three years has been the release. Artists are able to plunder so many different sources and attitudes, which would not be valid without the kind of literary-based rigorous examination of meaning that Conceptualism is about.'

These days British painters are appropriating ideas from primitive and folk art; from mythology; from British history; from poetry, children's literature, and fairy tales; from consumer culture, the urban environment, and current political events; from images, styles, techniques, and passages in traditional Western and in particular British painting; from travel; and from ideas— religious, political, psychological, philosophical, scientific. 'I like the play of ideas', says Steven Campbell, whose narrative paintings draw on the novels of P.G. Wodehouse, Michel Foucault's *Madness and Civilization*, and the theories of Charles Darwin. Campbell promises, 'I'm going to be very eclectic for a wee while. I'm going to steal left, right, and centre. Usually I try to take something dead normal and make it unusual and interesting for me. So maybe I'll start with the bizarre and work backwards. That's what Magritte does, doesn't he?'

Some British image-hunters are ranging much further afield than their local second-hand bookstores in their quest for images. For example, Simon Edmondson has been to Beirut and Poland; Jock McFadyen to Northern Ireland; John Keane to Nicaragua. Other painters bring back the colours, images and impressions from landscapes that are peaceful but utterly foreign to Britain: Stephen McKenna, the sight of the ruins of

bourhoods and small intimate repertory of relatives and friends provide the older generation of figurative painters with a never-ending source of images: Lucian Freud's Paddington; Frank Auerbach's Primrose Hill; Leon Kossoff's portrayals of his parents and brother. Also drawing their images from intimate sources are younger portrait painters: Tony Bevan, Mary Mabbutt and Simon Edmondson (although Edmondson also uses images from his travels); feminist painters who make the rhythms and life of their bodies into their subject: Eileen Cooper, Amanda Faulkner, and Gwen Hardie; and finally narrative

64 Ken Kiff. *Large Face above Water*. 1987. Watercolour, 11 × 8 in (27.9 × 20.3 cm). Courtesy Fischer Fine Art, London

65 Howard
Hodgkin. *Down in
the Valley*. 1985–8.
Oil on wood,
29 × 36 in
(73.6 × 91.4 cm).
Courtesy
Waddington
Galleries Ltd,
London

Pompeii; Irish-born Sean Scully, the green of the Italian countryside and the sturdy look of shanties and adobes in the American Southwest; Howard Hodgkin, the hot yellow and Mogul red dyes of India and blue-green waters of Venice; Peter Kinley, India's monkeys and sacred turtles.

Finally, a number of British painters explore awesome, uninhabited nature. In the catalogue for Ian McKeever's 1987 show *Echo and Reflection 1983–7*, there is a black-and-white photograph of the artist, his back to the camera, doggedly making his way across a stream that is like a black fissure in the endless white expanse of the Finnish winter. His solitude is so breathtaking that the question was asked almost involuntarily: 'What if something happened to you?'. McKeever said, 'I try to be careful.' He makes two such daunting trips a year (Pl. 66).

Current British painting refutes the ideas central to American Neo-Expressionism, Neo-Geo, and an emerging 'Hyper-modernism': that imagery has to come from the all encompassing visual media of film, photography, newspapers, and above all television; that replication is art; that feeling can be borrowed along with the image. (Plant a skull or crucifix in your painting, add oil paint, stir, and you have ready-made 'Significance'.) In British painting, by contrast, the artist's first-hand feeling initiates the painting, even if the image already comes with an emotional charge. In the process of painting, the artist's emotions transform the image, so that it emerges naturally out of the painting rather than being imposed from without.

Protesting the interchangeability of images in much Neo-Expressionist painting, Christopher Le Brun says that he doesn't want to force imagery into his work; it has to be completely in the weave of how the painting is made. Jock McFadyen describes trying, and then rejecting, the American approach of appropriating straight from the media. McFadyen, whose intention has always been to describe his times, particularly the urban context of his life in Mile End, East London, found that doing this by borrowing ready-made images from the media led to flatly painted, editorializing cartoons that eventually did not satisfy him. Accepting painting with all its limitations—its relative slowness, its elitism in a socialist society—McFadyen now paints 'emotional narratives' that are a direct response to something he has seen first-hand on the street: an Orange Day parade in Glasgow, for example, or Arabs in the Whatney market, or two tough young girls waiting to be picked up by a carful of 'lads'. McFadyen says that since his paintings of the denizens of bleak Mile End are first-hand experiences they are more instinctual, more personal, almost self-portraiture, and in the process they have become more painterly and plastic.

If there is a contrast in source between the new British and the new American imagery and sculpture—Allan McCollum's multi-

tudes of painted ginger jars which he calls 'perfect vehicles', Jeff Koons' basketballs in tanks of water, Robert Gober's sinks on the wall, Haim Steinbach's shelves of new boxes of detergent, Ashley Bickerton's pristine assembly-line auto parts, Peter Halley's day-glo acrylic Neo-Geo—there is even more of a contrast in the way the British and American artists handle their imagery. As we shall see, unlike the cool presentations of the Americans, the emotional investment of the British painter in his imagery is impossible to miss. This is true whether the British painter is borrowing from Italian opera or fairy tale, thereby heightening and distancing his or her own feelings; or whether painting narratives from storybooks or from neighbourhood life; or whether painting a common worn object, which has been elevated on a plinth, or an image brought back from travels; or whether painting a small vocabulary of recurrent images—a boat, a tower, a tree, a shield, a parachutist with a yellow parachute—with such loving care and obsessiveness that the objects' role as surrogate selves is unmistakable.

Americans have always constituted contemporary British art's largest percentage of collectors apart from the Saatchi family, who, in fact, have very little British art on show in their Collection. Since the mid-60s American galleries have been exhibiting the works of British painters Francis Bacon, American-born R.B. Kitaj, and David Hockney; and of the sculptors Anthony Caro, William Tucker, Richard Long and Barry Flanagan. At the beginning of the 1980s the work of a new generation of British sculptors—anti-formal, allusive, made from unorthodox materials and found objects—caught on in the United States. As the new sculpture evolves in dramatic ways, it continues to arouse strong American interest. Last year a seminal show *A Quiet Revolution: British Sculpture Since 1965* opened its year-long tour at the Museum of Contemporary Art, Chicago, featuring Tony Cragg, Richard Deacon, Barry Flanagan, Richard Long, David Nash and Bill Woodrow.

Since 1986 it has become clear that Americans are responding with even more enthusiasm to contemporary British painting. The Freud retrospective at the Hirshhorn Museum and Sculpture Garden in 1987 made a deep impression on the large crowds and the reviewers alike. During the *UK/LA 88* festival of British arts this year, Peter Goulds' LA Louver was one of the participating galleries. Goulds reports that his show, *The British Picture* (representing two generations of contemporary British figurative painters), and, in fact, the entire festival drew an 'unparalleled response' from American viewers. American interest in British painting has deepened, so that exhibitions of the Camden Town Group, Vorticism, the Bloomsbury Group, visionary painting, and the paintings of David Bomberg have been possible. At any given

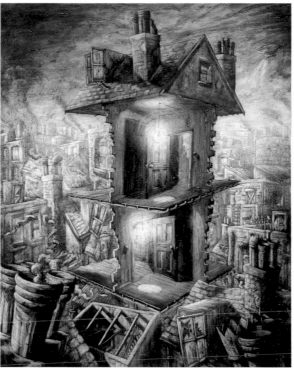
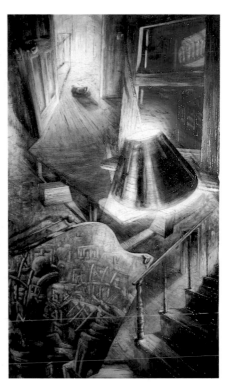

67 Graham Crowley.
Peripheral Vision.
1987

68 Ian McKeever.
The Rock Mushroom.
1987–8

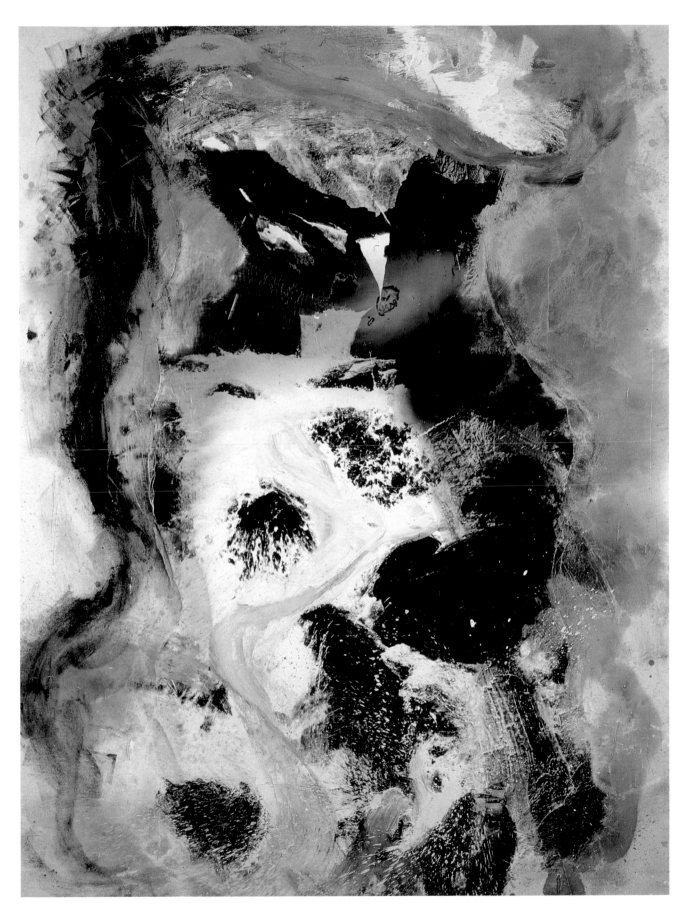

69 Ian McKeever.
Nightfall. 1986

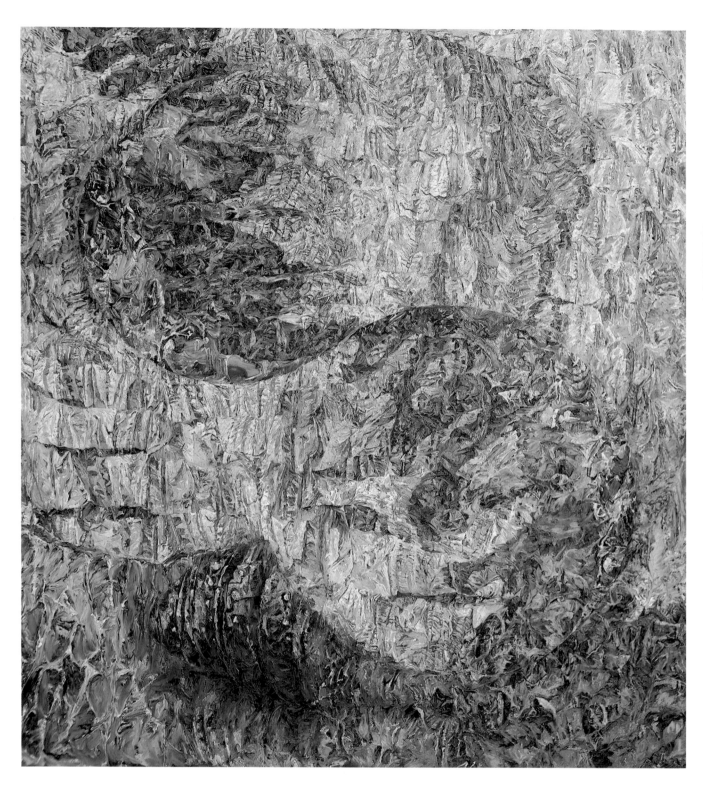

70 Thérèse Oulton.
Double Back. 1987

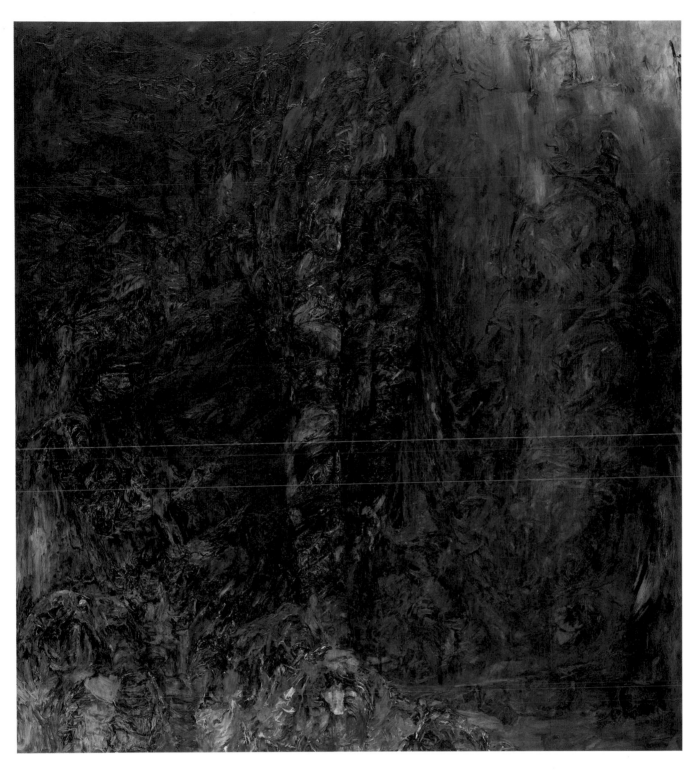

71 Thérèse Oulton.
Greek Gift (to Matilda).
1986

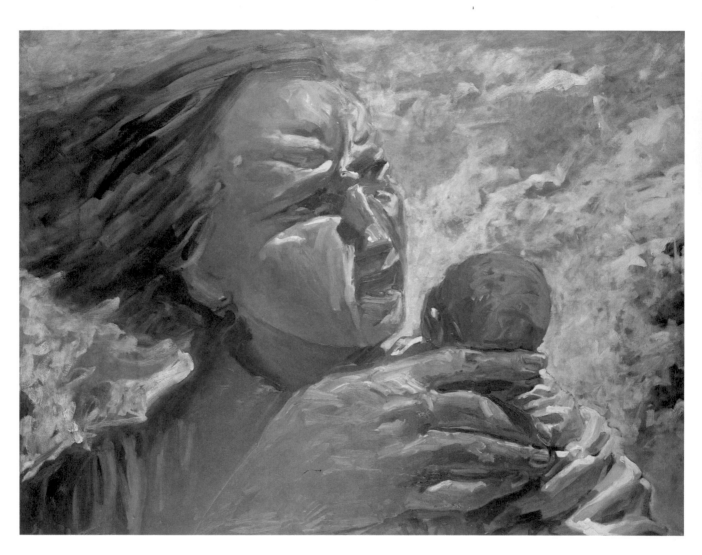

72 Kevin Sinnott.
Mother and Child.
1987

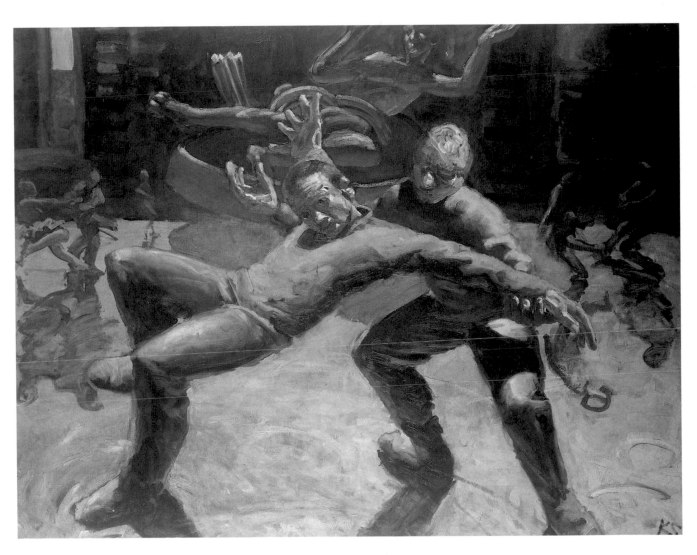

73 Kevin Sinnott.
Thin Ice. 1987

74 Suzanne Treister.
Electric Chairs. 1987

75 Suzanne Treister.
Detail of God's
Underwear. 1987

76 Mark Wallinger.
*In the Hands of the
Dilettanti.* 1986

77 Mark Wallinger.
Satire Sat Here. 1986

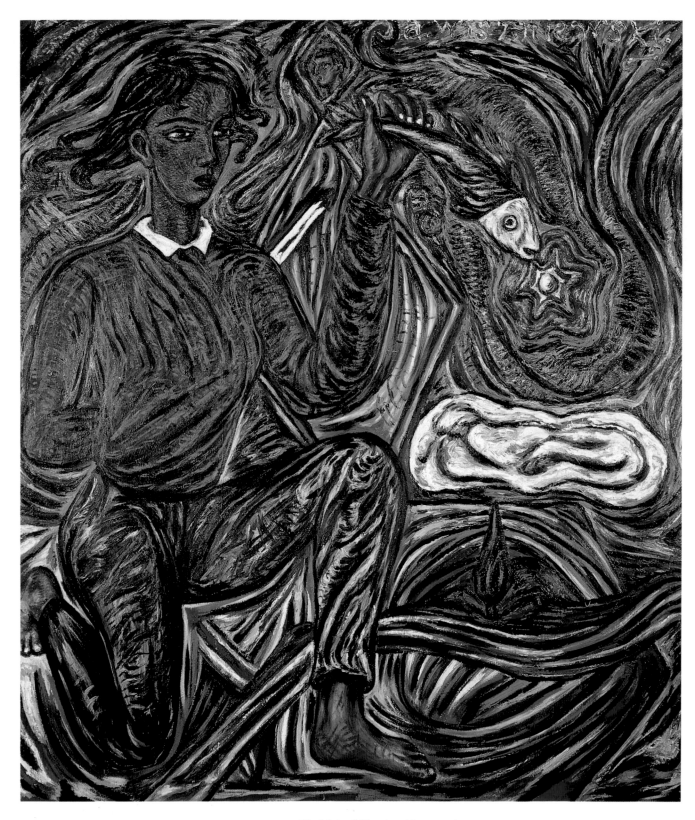

78 Adrian Wiszniewski.
Nuclear Fission. 1985

79 Adrian Wiszniewski.
Toying with Religion.
1987

80 Tim Head.
Prime Cuts. 1987

81 Tim Head.
Mutations. 1987

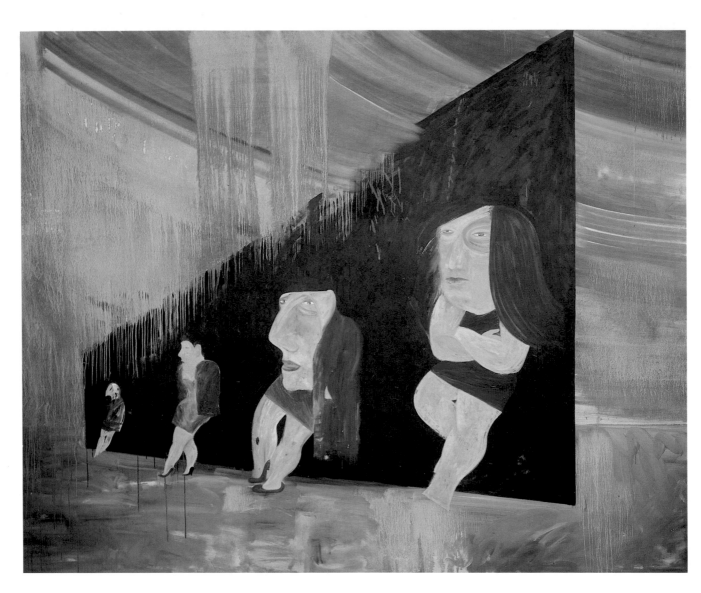

82 Jock McFadyen.
Rainy Day Women, L8.
1986

time there are British painters in individual or group exhibitions on 57th Street and in Soho, New York City, and increasingly on the West Coast of America.

This touring exhibition that begins at The Contemporary Arts Center, Cincinnati, is the largest group show to have come to the United States thus far. The Center's Director, Dennis Barrie, comments: 'The painters in the School of London are now acknowledged to be among the best in the world. Now it's time to show the work of the next generation of British artists who have been influenced by that School. They are at least as interesting as the Germans and Italians, and their work will have considerable impact over the next five to ten years'.

Over the past three years the Metropolitan Museum of Art, New York City, has purchased the work of over a dozen contemporary British painters who are in their twenties and thirties; the museum exhibited these works in the spring of 1988. Today, for museum and individual collectors alike a London stop-over is essential. The availability of contemporary British art and the fact that it is not yet overpriced account for some of its popularity with Americans. But the major reason is the art itself. British art has at last come into its own, no longer dominated by European Modernism, as it was until 1940, or by American movements, such as Abstract Expressionism, Pop Art, Conceptualism and Minimalism, as it was until 1980. British art is increasingly sought

83 Frank Auerbach. *Head of J.Y.M. – Profile.* 1987. Oil on canvas, 14$\frac{1}{4}$ × 16$\frac{1}{4}$ in (36.2 × 41.3 cm). Private collection

out by Americans for its native strengths and peculiarly British characteristics. Contemporary British art obviously fills needs on the part of the American viewer that are not being met by the current pluralism in American art and its focus on the cool, the geometric and the machine-made.

Richard Pomeroy discussed with me the response of some American viewers to the vivid painterly work in his new gallery on the London docks. Standing in the middle of the gallery, looking around, some Americans commented, 'Everything here is so *beautiful*—and there's nothing beautiful in New York.' Pomeroy added, 'I think art should be beautiful—maybe not beautiful physically, but it has to have a beauty of spirit.'

England has for many years had the greatest number of practising visual artists of any country (estimated at over 50,000) and the best support structure for artists— through the Arts Council, the British Council, the Contemporary Arts Society, and through SPACE Studios and ACME Studios and Housing, which since the late 1960s have subsidized living and working space for artists in factories and warehouses in London's East End and Docklands. To foreigners and first-generation Londoners, who have made such a significant contribution to British painting, this city with its stable matter-of-factness and flights of fancy has been a nurturing environment indeed.

Frank Auerbach, for whom London seems

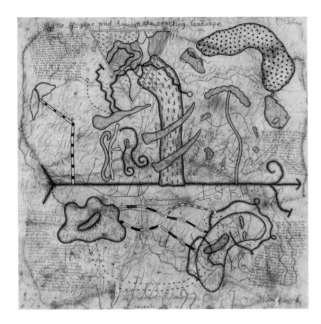

to be his landscape of the imagination, praises the 'wonderfully organic way London has grown'. He paints only people and places familiar to him: his wife, son, aunt, friends, fellow painters, models whom he has known for many years (Pl. 83), and what he refers to as 'my little corner' of London: the approach to his studio and nearby Primrose Hill. In a building of subsidized studios, surrounded by fellow artists who do not intrude, the Portuguese painter Paula Rego paints eight hours daily in a windowless studio that becomes her imaginary world each day. 'London is a wonderful city', she says, for the way it 'lets you get on with it'.

The British artist has always been at work, but it has taken the strong validation received from Europe and America to encourage the British art world and general public, who before the 1980s had been interested mainly in foreign historic and contemporary art, to take a second look at their own contemporary art and begin wholeheartedly supporting it. Today Howard Hodgkin, who exhibited for years in New York before he was exhibited at the Venice Biennale and at the Whitechapel Art Gallery, East London, would no longer be able to make his wry comment of a few years ago that, 'To do well in England one has to be a dead artist'. Now a gallery map of London has to be constantly revised, as new galleries open up, both on Cork Street and outside the West End: in the Docklands and

84 Simon Lewty. *Signs of Fear and Hope in the Cracking Landscape*. 1986. Crayon, charcoal, acrylic on paper, $57\frac{7}{8} \times 57\frac{1}{4}$ in (147×145.4 cm). Courtesy Anne Berthoud Gallery, London

Portobello Road, where there are a dozen new avant-garde galleries. Graham Paton, who considers his Covent Garden gallery to be an incubator for young talent, is seeing his prophecy of a few years ago coming true: 'The sculpture got off. Now British painting's going to go into international orbit!'

Today in Britain there is more museum space for contemporary art: the modern wing of the Tate Gallery, the Hayward and the Serpentine Galleries, the Scottish National Gallery of Modern Art in Edinburgh, the Saatchi Collection, an expanded Whitechapel Art Gallery, and now the new Tate Gallery in Liverpool, which is concentrating on modern and contemporary art, including performance art. Outside London, galleries such as the Arnolfini in Bristol, the Museum of Modern Art in Oxford and the Fruit Market Gallery in Edinburgh can be relied upon to mount provocative shows. Artists have the opportunity of winning the John Moores Prize, with an accompanying exhibition, and the Turner Prize, which has become more open by no longer permitting the same names to appear on the short list two years running.

Not only has the patronage of the Saatchi Collection been immensely helpful to young British artists, but the Saatchi example, the Medici factor, as one gallery owner puts it, can be expected to encourage other collectors. Indeed, there already is a new class of collectors in London, young and wealthy. However, it must be said that the major

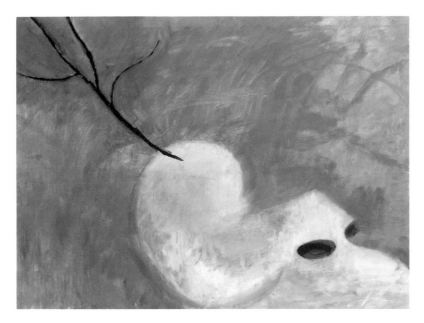

patrons have tended to concentrate on a very few artists: Sir Robert and Lady Sainsbury collected Henry Moore and Francis Bacon; the late Lord Dufferin, Hockney and Caro; the Duke of Devonshire, Lucian Freud. For the specialist, the well-distributed international magazine *Artscribe* has made a big difference, and a new magazine, *Modern Painters*, edited by Peter Fuller and based in London, is focusing on painting in the United Kingdom. Media coverage on art has widened to include the general public, with interviews of artists and articles in the London *Evening Standard* and glossy monthly magazines, such as *Tatler*, *Vogue*, and *Elle*.

In the midst of such energy and activity, the one gloomy note sounded is the fear that expected cutbacks in art subsidies on the part of the present government will close art schools and fine art departments. Painters who had made their living by part-time teaching are being forced to rely entirely upon the marketplace for their income. If there is a post-Modern dilemma in British painting, it is not over content and what is to be done in the new era, but over the directions and allegiances to pursue as contemporary British painting follows British sculpture into the international marketplace. Should painting remain traditional? Should it draw closer to Europe, undoing the bonds with American art and the New York art market? Or should it become international and participate in both European and American developments?

In debates and in reviews of such important shows as *The British Art Show: Old Allegiances and New Directions 1979–84* which toured Birmingham, Edinburgh, Sheffield, and Southampton in 1984–5; the 1986 Hayward Annual, *Falls the Shadow: Recent British and European Art*; and the Royal Academy's *British Art in the 20th Century* (1987), British artists, critics and dealers have expressed unease about the marketplace and about the fame of the new art, and have argued over the direction that British art should take. It is worth pointing out, however, that in a 1985 *Artscribe* debate on the prospects for British art, no matter how acerbic or pessimistic the comments were about British art's situation at this crossroads, all participants had nothing but the most positive things to say about the art itself. Their concern, in other words, has to do with a growing pride in the special strengths of British painting and a new-found faith that it is, as one dealer put it, 'more than a match for anything being produced in the world today'.

One of the characteristics of the painting represented in this exhibition, and mentioned in this essay, is the important connection to both Western and British painting traditions and genres. For the younger generation of British painters, as for the older, the past is still alive, whether they choose to perpetuate, revise, or overthrow its legacies. The past gives resonance and layers of meaning to

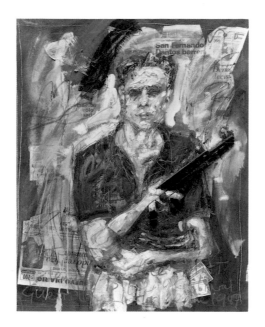

their work. Says Thérèse Oulton, 'You can criticize the power of the past at the same time that you are using it.'

The new painting is as broad-ranging as it is deep, with all the traditional British genres and a few new ones thriving: abstraction from nature; revitalizations of still life, the domestic interior, and romantic landscape painting; figurative and portrait painting; poetic landscape, visionary, and surreal painting; history painting, social satire, and critical realism; New Image, Scottish, and feminist painting.

Contemporary British paintings are slow paintings, that is, *all* images are more or less 'hard-won'. By enlisting time on their side—taking months, even years to complete a work—the young artists are rewarded when the painting 'starts to have a life of its own'. They set up imaginary worlds, both for themselves and for the viewer. Simon Lewty's palimpsests in code language of dreams and childhood, for example, are maps of lunar journeys toward self-recognition (Pl. 84). Just as the paintings of these artists have taken a long time to make, they take a long time to be seen, and as often as not require a new way of seeing.

These imaginary worlds are powered by apt, resonant, many-layered images. Whether coaxed forth from the paint or imposed from without, whether of the artist's inner self or of his or her environment, these images are not only of first-hand emotional significance to the artist but also well-

86 John Keane. *Portrait of the Artist Pretending to Be a Cultural Guerrilla.* 1987. Oil and mixed media on canvas, 46 × 36 in (116.8 × 91.4 cm). Courtesy Angela Flowers Gallery, London

observed and particular; feeling and reality conjoin in visual conceits of great impact. The imagination, daringly unleashed in contemporary British painting, juxtaposes, transforms, dramatizes, overturns. Think of Mark Wallinger's and Amanda Faulkner's subversions of cherished myths and ideas; of the anthropomorphic animals in the paintings of Paula Rego and Jock McFadyen; of Kevin Sinnott's fantasy dramas staged on city rooftops and streets, of Graham Crowley's leaps from the familiar and domestic to the surreal; of Lisa Milroy's, Suzanne Treister's, and Charlotte Verity's transformations of the still life (Pl. 85); of Andrzej Jackowski's and Ken Kiff's explorations of the dreaming, dreading subconscious; of Avis Newman's fluid complex images, both suggestive and precise, that look like palaeolithic cave art or dreams (Pl. 91); of Steven Campbell's trapdoor countrysides where the inspiration to try something bizarre or mischievous is never resisted.

Contemporary British painting, even when it is abstract, is not a cool art. The charged imagery, painterly energy, and obvious investment of time would be enough to convey its emotional intensity. But feeling is also heightened in several other ways: through the intimacy and self-revelation that the genre of personal mythology delivers; through theatricality; and through colour, mood, and light. As for the theatricality, Paula Rego, Stephen Conroy and Kevin

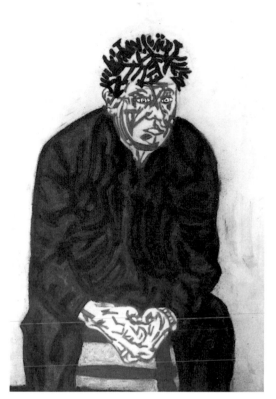

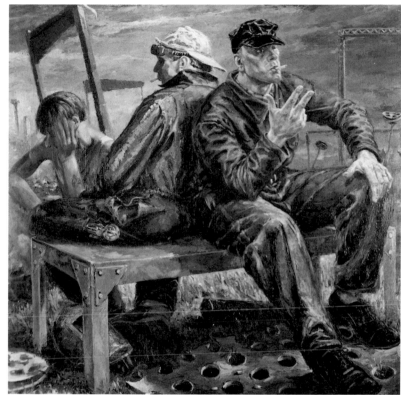

87 Tony Bevan.
Self-Portrait. 1987.
Pigment and
acrylic on canvas,
80 × 65 in
(203 × 165 cm).
Ronald Feldman
Fine Arts, New
York

88 Jonathan Waller.
On the Bench. 1988.
Oil on canvas,
84 × 84 in
(213.3 × 213.3 cm).
Private collection,
New York

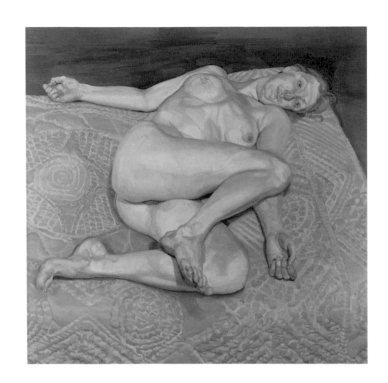

89 Lucian Freud.
Night Portrait.
1977–8. Oil on
canvas 28 × 28 in
(71 × 71 cm).
Private collection

90 Gwen Hardie.
Venus with Spikes.
1986. Oil on
canvas, 59 × 78¾ in
(150 × 200 cm).
Courtesy Paton
Gallery, London

91 Avis Newman.
*The Yes and No
Unsplit*. 1987.
Mixed media on
canvas, 108 × 165 in
(274.5 × 410 cm).
Courtesy Lisson
Gallery, London

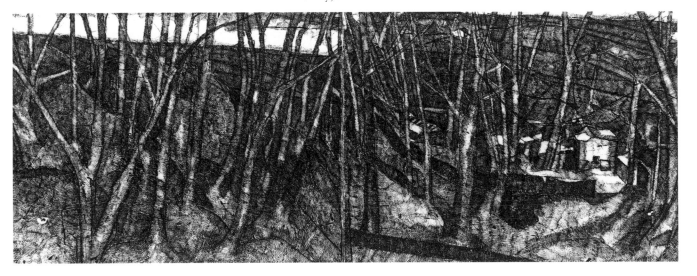

92 John Virtue.
Landscape No. 58.
1987. Pencil,
charcoal, shellac,
ink and gouache on
paper mounted on
board, 36 × 96 in
(91.5 × 244 cm).
Courtesy Lisson
Gallery, London

Sinnott set up dramatic tensions between separate figures. Mary Mabbutt dynamically angles her single figures; Stephen Barclay frames his alter ego in doorways; Kevin Sinnott and Eileen Cooper emphasize the monumentality of their figures by placing them in shallow spaces; Jonathan Waller confronts us head-on with his images of derelict locomotives; John Monks elevates his found objects on pedestals.

The current British painting uses colour and light symbolically. The hot side of the palette readily translates into feelings, in the paintings of Kiff, Jackowski, Peter Kinley, Hodgkin, McFadyen and Faulkner. But there is also a 'British palette' of overcast colours—dingy flesh, teal blue, forest green, brown—that has its own compelling melancholy mood and a strange eerie expectancy, as though these low-key colours and muddy verdure were the necessary prelude to a breakthrough of light and hot blossoming colours. British painters are masters of atmosphere, nuance, the glimmer of light in darkness. Think of the glimpses of precious ore in Thérèse Oulton's earthy embankments (Pl. 94), the white flickers in John Virtue's dark thickets (Pl. 92), the pallor of John Monks's suitcase against the green-black ground, and the salmon-pink skies over black cliffs in Simon Edmondson's landscapes, and most succinct of all the visionary white orb enveloped by black in Andrew Mansfield's metaphysical paintings (Pl. 93).

Finally, contemporary British art is hu-

93 Andrew Mansfield. *Consul.* 1987. Oil on canvas, 24 × 19½ in (61 × 50.3 cm). Courtesy Anthony Reynolds Gallery, London

manistic. It holds to Auerbach's conviction that: 'there is no more central and exciting subject than the whole human being wholly seen'. Even British landscape and object paintings refer to the human figure, the human condition. The concern of the School of London painters is with their model, someone they know well, whom they portray in their studio; whereas the younger generation of figurative painters, coming as they do after Modernism, abstraction, and the Conceptualist years when the figure was banished, are starting all over again: with the self, with the figure in new guises and in a wider social and psychological context. The focus of the younger painters, however, is if anything even more intensely on the human. Both introspective and socially concerned, John Keane's self-portrait reflects his ambivalence toward the capitalist system that supports him but also exploits war-torn Nicaragua (Pl. 86). Tony Bevan's spiky portraits get under the skin of Londoners from the East End—bag ladies, old men, drug addicts—and of himself (Pl. 87). Jonathan Waller's monumental figures in overalls, reflecting stoicism, apathy and despair, are metaphors for the devaluation of the work ethic in contemporary British society (Pl. 88). Gwen Hardie, aged twenty-six, could be speaking for both generations of British painters when she says, 'I'm fascinated by the figure—not in a representational, realistic way, but because I want to uncover all its metaphoric layers and dis-

94 Thérèse Oulton.
Voice. 1984. Oil on
canvas, 92 × 84 in
(233.6 × 213.3 cm).
Private collection

cover different aspects of it. For me the most intense thing is the fact that you're alive and you walk on two feet. I'm quite amazed at existence.' (Pl. 90)

The hunger on the part of the American viewing public to see the human being portrayed with both an inner life and an animal reality was evident in their over-whelming response to the retrospective of Lucian Freud's paintings last year in Washington, DC. In adjacent rooms at the Hirshhorn, American artists William Beckman, Jack Beal, Philip Pearlstein and Alex Katz presented the human figure as simply one component in their compositions and with the detailed perfection of retouched photography. The bodies were flat and weightless—expanses of unblemished pink plastic or pink rubber *skin* (as opposed to *flesh*). There was no question of any life going on inside that skin. Those exhibition rooms were almost empty, while the record-breaking crowds seemed unnerved, thoroughly absorbed in responses, even in awe, as they moved slowly through the Freud

exhibition of 'naked portraits', each one an almost tangible physical encounter with another human being (Pl. 89). These bodies expressed both quirky singularity and generic likeness. One felt their animality, the drag of gravity, the passage of time, often their existential sadness. Above all, the exhibition was about flesh—the mashed, grey-ish, not yet unfurled flesh of a newborn infant, the flesh of a young girl sleekly plump and gleaming like liquid; flesh battered, full of little bumps of light and dents of darkness in the self-portrait of the artist at the age of sixty-three. In all these envelopes of skin there was turbulent life.

Says gallery director Peter Goulds, 'As human beings we are particularly interested in the human condition. As it is a fact that so many artistic values in British painting are centred around the study and reflection of the human figure and its emotional context, it was only a matter of time for the public outside the community of English artists to pay attention to, and see the value of, the art being made in Great Britain today.'

CHECKLIST OF EXHIBITED WORKS

Stephen Barclay

The Parachutist. 1986. Pl. 13
Mixed media on paper
51½ × 42¾ in (130.8 × 108.6 cm)
Collection Colin Barnes, London

Night Tower. 1987. Pl. 12
Mixed media on paper
29 × 21 in (73.7 × 53.3 cm)
Collection Charles Greenwood, London

Steven Campbell

'Twas once an Architect's Office in Wee Nook.
1984. Pl. 10
Oil on canvas
115 × 95 in (292 × 241 cm)
Collection Bette Ziegler, New York

A Salty Tale: In a Drought a Man Saves a Whale by his Perspiration and Tears. 1985.
Pl. 9
Oil on canvas
106 × 100 in (269.2 × 254 cm)
Collection Susan Kasen and Robert D.
Summer, New York

The Man who Gave his Legs to God and God Did not Want them. 1987. Pl. 11
Oil on canvas
94 × 82½ in (239 × 209.5 cm)
Collection Susan Kasen and Robert D.
Summer, New York

Stephen Conroy

167 Renfrew Street. 1986. Pl. 14
Oil on canvas
48 × 48 in (122 × 122 cm)
Collection the artist

Wireless Vision Accomplished. 1987. Pl. 15
Oil on canvas
54 × 48 in (137 × 122 cm)
Collection Robert Fleming Holdings Ltd,
London

Eileen Cooper

Babies. 1987. Pl. 56
Oil on canvas
48 × 54 in (122 × 137.2 cm)
Courtesy Benjamin Rhodes Gallery,
London

If the Shoe Fits. 1987. Pl. 55
Oil on canvas
48 × 36 in (121.9 × 91.4 cm)
Courtesy Benjamin Rhodes Gallery,
London

Over the Side. 1987. Pl. 57
Oil on canvas
36 × 28 in (91.4 × 71 cm)
Collection J. Melgar, England

Graham Crowley

Peripheral Vision. 1987. Pl. 67
Oil on canvas
80 × 134 in (203 × 340.4 cm)
Courtesy Edward Totah Gallery, London

Ken Currie

In the City Bar. 1987. Pl. 19
Oil on canvas
83 × 146 in (210.8 × 370.8 cm)
Collection Susan Kasen and Robert D.
Summer, New York

Workshop of the World (Hope and Optimism in Spite of Present Difficulties). 1987. Pl. 20
Oil on canvas
84 × 108 in (213.4 × 274.3 cm)
Collection the artist

Simon Edmondson

Elements. 1986. Pl. 22
Oil on canvas
83 × 74 in (210.8 × 188 cm)
Collection Stephen A. Solovy Art
Foundation, Chicago

A Hundred Ardent Lovers Fell into Eternal Sleep. 1987. Pl. 21
Oil on canvas
90 × 92 in (229 × 234 cm)
Collection Stephen A. Solovy Art
Foundation, Chicago

Amanda Faulkner

Inside Out. 1985. Pl. 24
Acrylic on canvas
76 × 87½ in (193 × 222 cm)
Private collection, courtesy Angela
Flowers Gallery, London

Dirty Faces. 1987. Pl. 23
Acrylic on canvas
68 × 80⅜ in (173 × 205 cm)
Courtesy Angela Flowers Gallery, London

Gwen Hardie

Head 1. 1985. Pl. 1
Oil on canvas
76 × 68 in (193 × 173 cm)
Collection Ken Powell, London

The Brave One. 1987. Pl. 25
Oil on canvas
78 × 78 in (198 × 198 cm)
Collection the artist

Tim Head

Mutations. 1987. Pl. 81
Acrylic on canvas
60 × 84 in (152.4 × 213.4 cm)
Courtesy Anthony Reynolds Gallery, London

Prime Cuts. 1987. Pl. 80
Acrylic on canvas
60 × 84 in (152.4 × 213.4 cm)
Courtesy Anthony Reynolds Gallery, London

Peter Howson

For Love nor Money. 1987. Pl. 46
Oil on canvas
101 × 108 in (254 × 274.5 cm)
Ian Flooks, courtesy Angela Flowers
Gallery, London

A Wing and a Prayer. 1987. Pl. 45
Oil on canvas
96 × 84 in (244 × 213.5 cm)
Collection Susan Kasen and Robert D.
Summer, New York

Andrzej Jackowski

Settlement—with Three Towers. 1986. Pl. 48
Oil on canvas
60 × 92 in (152.4 × 233.7 cm)
Courtesy Marlborough Fine Art, London

Earth-Stalker. 1987. Pl. 47
Oil on canvas
60 × 92 in (152.4 × 233.7 cm)
Courtesy Marlborough Fine Art, London

John Keane

Who You Are and What You Do. 1986–7. Pl. 53
Oil and mixed media on canvas
96 × 68 in (244 × 173 cm)
Courtesy Angela Flowers Gallery, London

New British Landscape. 1987. Pl. 54
Oil and mixed media on canvas
90 × 69 in (228.6 × 175.3 cm)
Courtesy Angela Flowers Gallery, London

Christopher Le Brun

Wake. 1984. Pl. 16
Oil on canvas
100 × 101 in (254 × 259 cm)
Courtesy L.A. Louver Gallery, Venice,
California

Tree with Hill. 1987. Pl. 17
Oil on canvas
70 × 65½ in (178 × 167 cm)
Courtesy Nigel Greenwood Gallery, London

Mary Mabbutt

New Shoes. 1983. Pl. 50
Oil on canvas
72 × 78 in (182.9 × 198 cm)
Collection Pentland Industries, London

Walking on the Beach. 1985. Pl. 49
Oil on canvas
48 × 38 in (122 × 96.5 cm)
Collection John D. Farnworth, Bedford

Jock McFadyen

Parade. 1986. Pl. 18
Oil on canvas
84 × 100 in (213.4 × 254 cm)
Collection the artist

Rainy Day Women, L8. 1986. Pl. 82
Oil on canvas
84 × 104 in (213.4 × 264.2 cm)
Collection the artist

Ian McKeever

Nightfall. 1986. Pl. 69
Oil and photograph on canvas
87 × 67 in (221 × 170 cm)
Courtesy the artist and Galerie Tanit,
Munich

The Rock Mushroom. 1987–8. Pl. 68
Oil, acrylic, photograph on canvas
90 × 175 in (230 × 445 cm)
Courtesy the artist and Galerie Alexander
Hodel, Zurich

Lisa Milroy

Fans. 1986. Pl. 43
Oil on canvas
75 × 97 in (190.5 × 246.4 cm)
Collection Marilyn Chernoff, Bloomfield
Hills, Michigan

Shirts. 1986. Pl. 44
Oil on canvas
78¼ × 74 in (198.6 × 188 cm)
Collection Steven A. Lapper, Chicago

Fragments. 1987. Pl. 42
Oil on canvas
80 × 102 in (203.2 × 259 cm)
Courtesy Jack Shainman Gallery, New York

John Monks

Suitcase with Glove. 1985. Pl. 51
Oil on canvas
72 × 54 in (182.9 × 137.2 cm)
Collection Metropolitan Museum of Art,
New York, Purchase Mr & Mrs Roy B.
Simpson Gift 1986 (1986. 228)

Car Door. 1986. Pl. 52
Oil on canvas
72 × 46¾ in (182.9 × 118.8 cm)
Private collection, London

Thérèse Oulton

Greek Gift (to Matilda). 1986. Pl. 71
Oil on canvas
93¼ × 85¼ in (236.8 × 216.5 cm)
Courtesy L.A. Louver Gallery, Venice,
California

Double Back. 1987. Pl. 70
Oil on canvas
92 × 84 in (233.7 × 213.4 cm)
Collection Mr and Mrs Joe Cayre,
New York

Kevin Sinnott

Mother and Child. 1987. Pl. 72
Oil on canvas
56 × 74 in (142 × 188 cm)
Courtesy Bernard Jacobson Gallery, London

Thin Ice. 1987. Pl. 73
Oil on canvas
62 × 80 in (157.5 × 203 cm)
Courtesy Bernard Jacobson Gallery, London

Suzanne Treister

Detail of God's Underwear. 1987. Pl. 75
Oil on canvas
86 × 60 in (218.4 × 152.5 cm)
Courtesy Edward Totah Gallery, London

Electric Chairs. 1987. Pl. 74
Oil on canvas
84 × 74 in (213 × 183 cm)
Courtesy Edward Totah Gallery, London

John Virtue

Landscape No. 8. 1980–4. (Frontispiece)
Ink on paper laid on board
75 × 94 in (190.5 × 238.8 cm)
Courtesy L.A. Louver Gallery, Venice,
California

Landscape No. 28. 1985–6. Pl. 41
Black ink, pencil, charcoal, shellac and
gouache on paper laid on board
44 × 92 in (110 × 233 cm)
Courtesy L.A. Louver Gallery, Venice,
California

Jonathan Waller

Sequel. 1987. Pl. 58
Oil on canvas
96 × 120 in (two panels, 96 × 60 in each)
(244 × 305 cm)
Courtesy Sir Charles Chadwyck-Healey,
Cambridge, England

Mark Wallinger

In the Hands of the Dilettanti. 1986. Pl. 76
Oil on canvas
60 × 84 in (152.5 × 213.5 cm)
Courtesy Anthony Reynolds Gallery, London

Satire Sat Here. 1986. Pl. 77
Oil on canvas
84 × 120 in (213.5 × 305 cm) (two panels,
84 × 60 in each)
Courtesy Anthony Reynolds Gallery, London

Adrian Wiszniewski

Nuclear Fission. 1985. Pl. 78
Oil on canvas
84 × 72 in (213.4 × 182.9 cm)
Collection Susan Kasen and Robert D.
Summer, New York

Toying with Religion. 1987. Pl. 79
Oil on canvas
96 × 77 in (244 × 195.6 cm)
Courtesy Nigel Greenwood Gallery, London

THE ARTISTS

Stephen Barclay

Born in Ayrshire 1961. Studied at Glasgow School of Art 1980–5; was awarded an Adam Bruce Thomson Award from the Royal Scottish Academy in 1984. Included in the *New Image: Glasgow* exhibition which toured Great Britain in 1985. First one-man exhibition in London 1987. Lives and works in Scotland.

Steven Campbell

Born in Glasgow 1953. Worked at steel works as a Maintenance Engineer 1970–7. Studied at Glasgow School of Art 1978–82. Lived and worked in New York 1982–6. First one-person exhibition at Barbara Toll Fine Arts, New York, 1983. Has since held one-person exhibitions in New York, Chicago, Munich, London, Edinburgh, Washington DC, Berlin, Geneva and San Francisco.

Stephen Conroy

Born in Helensburgh, Scotland, 1964. Studied at Glasgow School of Art 1982–6 (and postgraduate studies 1986–7). First one-man exhibition, Dumbarton District Council 1986; a second one-man exhibition is scheduled for London 1988.

Eileen Cooper

Born in Glossop, Derbyshire, 1953. Studied at Goldsmiths' College 1971–4, and at the Royal College of Art 1974–7. First one-woman exhibition in London 1979; has since had one-woman shows in London, Aberdeen, Manchester and Bath. Is currently a part-time lecturer at St Martin's and Camberwell Schools of Art, and an external examiner at the Slade School of Art.

Graham Crowley

Born in Romford 1950. Studied at St Martin's School of Art 1968–72, and at the Royal College of Art 1972. Artist in Residence to Oxford University 1982–3, and Visiting Fellow at St Edmund Hall. Member of Faculty Board (School of Painting) at the British School in Rome, 1981 to date. First one-man exhibition in London 1982; has since held four exhibitions in London, one in New York, a touring show based on the Museum of Modern Art, Oxford, and another based on Orchard Gallery, Londonderry, Northern Ireland. Currently lives and works in Cardiff.

Ken Currie

Born in North Shields 1960. Studied social science at Paisley College 1977–8. Studied at Glasgow School of Art, 1978–83. First one-person exhibition, *Art and Social Commitment*, at Glasgow Arts Centre 1983. Has since held one-person exhibitions in Bristol and London (Raab Gallery). Produces murals as well as easel-paintings.

Simon Edmondson

Born in London 1955. Studied at City and Guilds School of Art 1973–4, at Kingston Polytechnic 1974–7, and at Syracuse University, New York, 1978–80. First one-man exhibition in Syracuse 1979; has since had one-man shows in London, Berlin, Zurich and New York.

Amanda Faulkner

Born in Dorset 1953. Studied at Bournemouth College of Art and Design 1978–9, at Ravensbourne College of Art and Design 1979–82, and at Chelsea School of Art 1982. First one-woman exhibition in London 1983; has since had two more one-woman shows in London. Lives and works in Stoke Newington, London.

Gwen Hardie

Born in Newport, Fife, 1962. Studied at Edinburgh College of Art 1979–84. First one-woman exhibition in Glasgow 1984; has since had one-woman shows in London, Edinburgh, Dundee and Aberdeen. Currently lives in West Berlin.

Tim Head

Born in London 1946. Studied at University of Newcastle-upon-Tyne 1965–9, and at St Martin's School of Art 1969–70. Worked as assistant to Niki de St Phalle at Stedelijk Museum, Amsterdam, 1967; as assistant to Claes Oldenburg in New York, 1969; and as assistant to Robert Morris at the Tate Gallery, London, 1971. Held a Fellowship at Clare Hall and Kettle's Yard, Cambridge, 1977–8. First one-person exhibition at Museum of Modern Art, Oxford, 1972; since then has had numerous one-person exhibitions, mainly in Europe.

Peter Howson

Born in London 1958; moved to Scotland 1962. Studied at Glasgow School of Art 1975–9, then spent two years in the Scottish infantry and doing a variety of odd jobs. Artist in residence at St Andrews University 1985. Part-time tutor, Glasgow College of Art. First one-man exhibition, of mural drawings, at Feltham Community Association, London, 1982. Since then has had one-man exhibitions in Glasgow, St Andrews and London.

Andrzej Jackowski

Born in Penley, North Wales, 1947. Studied at Camberwell School of Art 1966–7, at Falmouth School of Art 1967–9 and 1972–3, and at the Royal College of Art 1974–7. First one-person exhibition at University of Surrey 1978. Has since had two one-person exhibitions in London (most recently at Marlborough Fine Art 1986) and a touring exhibition based on Bluecoat Gallery, Liverpool.

John Keane

Born in Hertfordshire 1954. Studied at Camberwell School of Art 1972–6. Artist in residence at Whitefield School, London, 1987. Has held six one-man exhibitions in London since 1980.

Christopher Le Brun

Born in Portsmouth 1951. Studied at Slade School of Art 1970–4, and at Chelsea School of Art 1974–5. First one-man exhibition in London 1980; has since held one-man shows in Paris, New York, Edinburgh, Basle, Bristol, Stromness (Orkney), Berlin and Cologne. Designed a new production of George Balanchine's *Ballet Imperial* for the Royal Ballet at Royal Opera House, Covent Garden, 1985.

Mary Mabbutt

Born in Luton 1951. Studied at Luton College of Art 1970–1, at Loughborough College of Art 1971–4, and at the Royal Academy Schools, London, 1975–8. Junior Fellow in Painting at South Glamorgan Institute of Higher Education 1978–9. Since 1979 has been part-time lecturer in painting at various art schools in England. Has had two one-woman exhibitions in London, the first in 1980.

Jock McFadyen

Born in Paisley, Scotland, 1950. Studied at Chelsea School of Art 1973–4. First one-man exhibition in London 1978. Has since had seven one-man exhibitions in London; one-man shows in Jarrow, Leeds and Glasgow; and an exhibition travelling to Sunderland, Birmingham, Stoke-on-Trent, Bolton, Hull, Belfast and London. Lives in London and is currently part-time lecturer at the Slade School of Art.

Ian McKeever

Born in Withersea, Yorkshire, 1946. Studied at Avery Hill College of Education, then lived and worked in London. First one-person exhibition Cardiff Arts Centre 1971. Has since held one-person exhibitions in London (1973), Birmingham, Venice, Newcastle, Trieste, Warsaw, Bristol, Glasgow, Liverpool, Oxford, Nuremberg, Düsseldorf, Munich, Southampton, Vienna, Cologne, Stuttgart, Helsinki, Innsbruck, Hamburg, Braunschweig, Preston, Haselt, Cologne and Zurich.

Lisa Milroy

Born Vancouver, Canada, 1959. Studied at the Sorbonne 1977–8, at St Martin's School of Art 1978–9, and at Goldsmiths' College 1979–82. First one-person exhibition in London 1984. Has since held one-person exhibitions in Paris (at Fondation Cartier), San Francisco, and London (most recently at Nicola Jacobs Gallery 1988).

John Monks

Born in Manchester 1954. Studied at Liverpool College of Art 1972–5, and at the Royal College of Art 1977–80. First one-person exhibition at Hull College of Art 1981; has since had two solo exhibitions in London. Visiting artist at Garner Tullis Workshop, Santa Barbara, 1987.

Thérèse Oulton

Born in Shrewsbury 1953. Studied at St Martin's School of Art 1975–9, and at the Royal College of Art 1980–3. First one-person exhibition at Gimpel Fils, London, 1984. Has since held one-person exhibitions in Oxford 1985; Vienna, Munich and Berlin 1986; New York (Hirsch and Adler) and London (Marlborough Fine Art) 1988. She was a finalist for the Turner Prize in 1987.

Kevin Sinnott

Born in Wales 1947. Studied at Gloucester College of Art and Design 1968–71 and the Royal College of Art 1971–4. Part-time tutor at St Martin's School of Art. Recent one-man exhibitions include Birmingham, London, Cardiff and New York.

Suzanne Treister

Born in England 1958. Studied at St Martin's School of Art 1978–81, and at Chelsea School of Art 1981–2. Has participated in numerous mixed exhibitions in Britain 1985–7 and held two one-person shows at Edward Totah Gallery, London, 1985 and 1988.

John Virtue

Born in Lancashire 1947. Studied at Slade School of Art 1965–9. First one-person exhibition at Bede Gallery, Jarrow, 1972. Since then has held three exhibitions at Lisson Gallery, London, and one-person exhibitions at Kendal, Keele University, York University and in Los Angeles. Has lived and worked at Green Haworth since 1971.

Jonathan Waller

Born at Stratford-upon-Avon 1956. Studied at Lanchester Polytechnic, Coventry, 1980–3, and at Chelsea School of Art 1984–5. First one-person exhibition at Nene College, Northampton, 1984. Has since had solo exhibitions in Coventry and twice in London. Held the Junior Painting Fellowship at Cardiff 1985–6.

Mark Wallinger

Born at Chigwell, Essex, 1959. Studied at Loughton College, Essex, 1977–8, and at Chelsea School of Art 1978–81. MA course at Goldsmiths' College 1985–6. First one-person exhibition at The Minories, Colchester, 1983; has since held two one-person shows in London. His work has been seen in mixed exhibitions at Bard College, Annandale-on-Hudson; in New York; and in Australia (British Council Touring Exhibition).

Adrian Wiszniewski

Born in Glasgow 1958. Studied at Mackintosh School of Architecture 1975–9, and at Glasgow School of Art 1979–83. First one-man exhibition at Compass Gallery, Glasgow, 1984. Since then has had one-man shows in London and Liverpool.

SELECT BIBLIOGRAPHY

Art of our Time: The Saatchi Collection, 4 vols., Lund Humphries, London, 1984; Rizzoli, New York, 1985

Lewis Biggs and David Elliott, *Current Affairs: British Painting and Sculpture in the 1980s*, Museum of Modern Art, Oxford, 1987

British Art in the 20th Century: The Modern Movement, Royal Academy of Arts, London, and Prestel-Verlag, Munich, 1987

The British Art Show: Old Allegiances and New Directions 1979–84 (Arts Council of Great Britain), Orbis, London, 1984

The British Show (British Council), Art Gallery of New South Wales, 1985

Carnegie International 1985, Museum of Art, Carnegie Institute, Pittsburgh, 1985

Falls the Shadow: Recent British & European Art, The Hayward Annual, 1986, Arts Council of Great Britain, London, 1986

Tony Godfrey, *The New Image: Painting in the 1980s*, Phaidon Press, Oxford, 1986

Charles Harrison, *English Art and Modernism, 1900–1939*, Allen Lane, London, and Indiana University Press, Bloomington, 1981

'Likely Prospects: A British Art Questionnaire', *Artscribe* No. 50, January–February 1985

Richard Morphet, *The Hard-Won Image: Traditional Method and Subject in Recent British Art*, Tate Gallery, London, 1984

Sandy Nairne, *State of the Art: Ideas and Images in the 1980s*, Chatto & Windus, London, 1987

Terry A. Neff (ed.), *A Quiet Revolution: British Sculpture Since 1965*, Museum of Contemporary Art, Chicago; Thames & Hudson, London, 1987

Roy Oxlade, *David Bomberg, 1890–1957*, RCA Papers No. 3, Royal College of Art, London, 1977

The Pre-Raphaelites, Tate Gallery and Penguin Books, London, 1984

The Proper Study: Contemporary Figurative Paintings from Britain, British Council, London, 1984

John Russell and Suzi Gablik, *Pop Art Redefined*, Thames and Hudson, London, 1969

Jerry Saltz, with essays by Roberta Smith and Peter Halley, *Beyond Boundaries: New York's New Art*, Van der Marck, New York, 1987

Richard Shone, *The Century of Change: British Painting since 1900*, Phaidon Press, Oxford, 1977

Frances Spalding, *British Art since 1900*, Thames & Hudson, London, 1986

Stanley Spencer RA, Royal Academy of Arts and Weidenfeld and Nicholson, London, 1981

Julian Treuherz, *Hard Times: Social Realism in Victorian Art*, Lund Humphries, London, and Moyer Bell, Mt. Kisco, New York, in association with Manchester City Art Galleries, 1987

Nicholas Usherwood, *The Brotherhood of Ruralists*, Lund Humphries, London, 1981

The Vigorous Imagination: New Scottish Art, Scottish National Gallery of Modern Art, Edinburgh, 1987

Heather Waddell, 'Extraordinary Changes: The British and Irish Art Scene', *Artnews*, December 1986

LENDERS TO THE EXHIBITION

Colin Barnes, London
Mr and Mrs Joe Cayre, New York
Sir Charles Chadwyck-Healey, Cambridge, England
Marilyn Chernoff, Bloomfield Hills, Michigan
Stephen Conroy, Dunbartonshire, Scotland
Ken Currie, Glasgow
John D. Farnworth, Bedford
Robert Fleming Holdings Limited, London
Ian Flooks, London
Angela Flowers Gallery, London
Charles Greenwood, London
Nigel Greenwood Gallery, London
Gwen Hardie, Berlin
Tim Head, London
Galerie Alexander Hodel, Zurich
Bernard Jacobson Gallery, London
Susan Kasen and Robert D. Summer, New York
Steven A. Lapper, Chicago

L.A. Louver Gallery, Venice, California
Jock McFadyen, London
Ian McKeever, London
Marlborough Fine Art, London
J. Melgar, England
Metropolitan Museum of Art, New York
Paton Gallery, London
Pentland Industries, London
Ken Powell, London
Private collection, London
Anthony Reynolds Gallery, London
Benjamin Rhodes Gallery, London
Jack Shainman Gallery, New York
Steven A. Solovy Art Foundation, Chicago
Galerie Tanit, Munich
Edward Totah Gallery, London
Mark Wallinger, London
Bette Ziegler, New York

Photographic Acknowledgements

The publishers with to thank the owners, museums, galleries, photographers and others who have contributed towards the reproductions in this book. Further acknowledgement is made to the following (figures indicate Plate numbers):
39 Des Moines Art Center, Coffin Fine Arts Trust; 40 National Museums and Galleries on Merseyside (Walker Art Gallery, Liverpool); 85 Photo by William Nettles. Courtesy Anne Berthoud Gallery, London; 47, 48 Photo Prudence Cuming Associates Ltd, London; 30 © Cosmopress, Geneva/DACS, London 1988; 33 Photo courtesy Gimpel Fils; 27 By kind permission of the Trustees of the Imperial War Museum; 89 Courtesy James Kirkman Ltd; 83 Courtesy Marlborough Fine Art; 2, 3 Reproduced by courtesy of the Trustees, The National Gallery, London; 76, 77, 80, 81 Photo by Susan Ormerod; 88 Courtesy Paton Gallery, London; 58 Photo Paton Gallery, London; 63 Courtesy Sarema Press. Photo by Prudence Cuming Associates Ltd, London; 73 Photo by Miki Slingsby, London; 68, 69 Photo by Eileen Tweedy, London; 42, 55, 56, 57 Photo by Gareth Winters, London; 26 © Henry Moore Foundation (1988). Reproduced by kind permission of the Henry Moore Foundation; 51 Photo by Lynton Gardiner; 31 Published by permission of the Sheffield City Art Galleries.

INDEX